D1577459

# GOYA'S *Caprichos*

# GOYA'S
# *Caprichos*

*by* JOSÉ LÓPEZ-REY

# *Beauty, Reason & Caricature*

VOLUME TWO

GREENWOOD PRESS, PUBLISHERS
WESTPORT, CONNECTICUT

*The photographs used for the following illus-
trations are from Más, Barcelona, Spain*

3, 4, 5, 6, 9, 10, 13, 14, 19, 20, 27, 28, 43,
44, 66, 67, 68, 69, 70, 75, 76-84, 89, 91, 93,
95, 97, 103, 104, 108, 110, 111, 113, 118, 123,
125, 128, 132, 135, 139, 141, 143, 146, 150,
153, 156, 158, 163, 166, 168, 170, 172, 173,
175, 177, 179, 181, 183, 185, 187, 188, 190,
192, 194, 196, 198, 200, 203, 205, 207, 211,
213, 215, 217, 223, 232, 234, 235, 238, 240,
241, 243, 245, 247, 249, 254

The original leaf of Figs. 15 and 16 was pur-
chased from the estate of Felix Wildenstein in
November 1952 by the Art Museum of
Princeton University.

# ILLUSTRATIONS

### DRAWINGS FROM THE SANLÚCAR SKETCHBOOK

### DRAWINGS FROM THE MADRID SKETCHBOOK

GOYA'S *Caprichos*

A few of Goya's captions on the margin of the
drawings have been reproduced separately for
greater clarity.

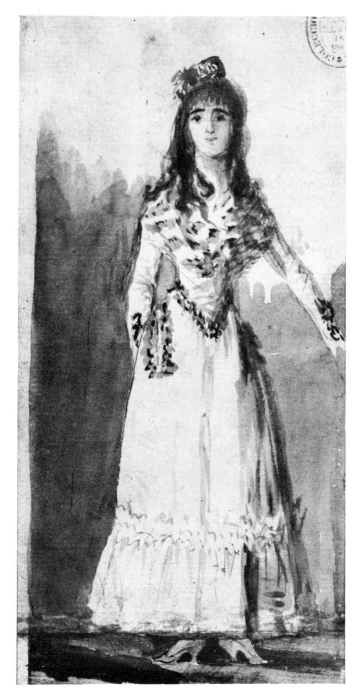

FIG. I

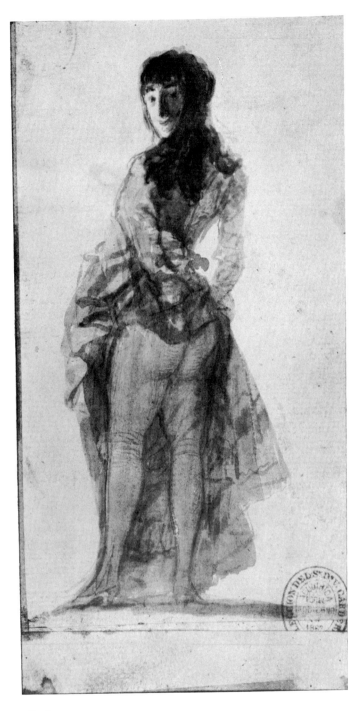

FIG. 2

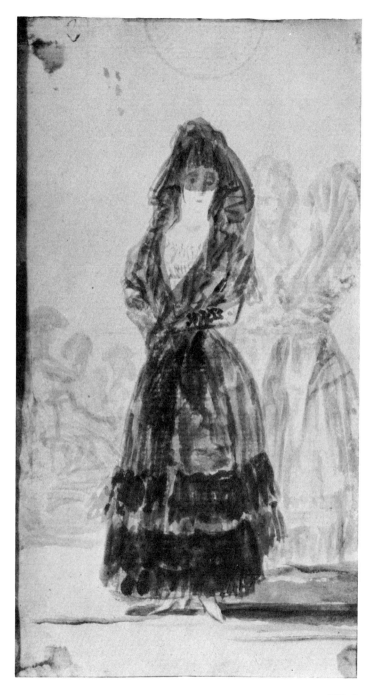

FIG. 3

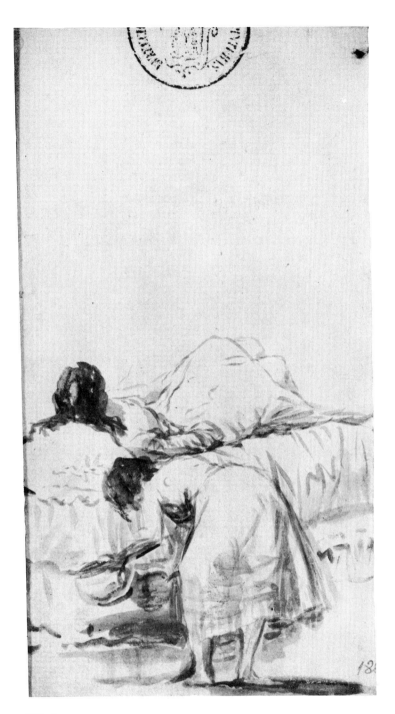

FIG. 4

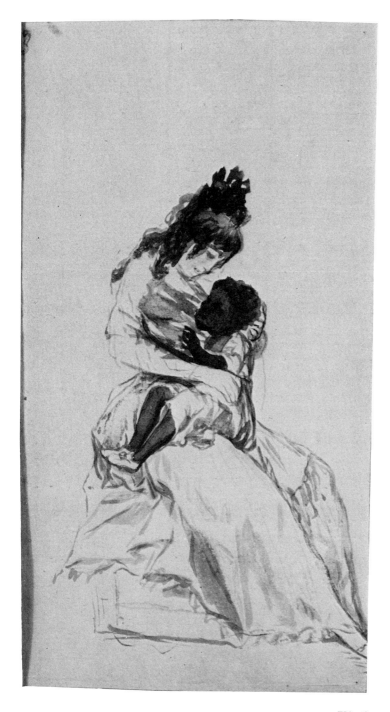

FIG. 5

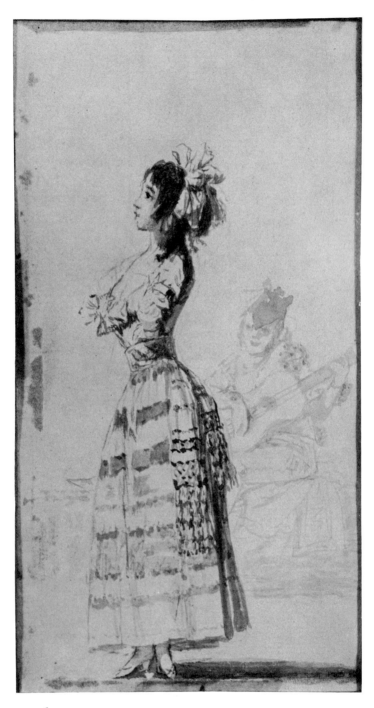

FIG. 6

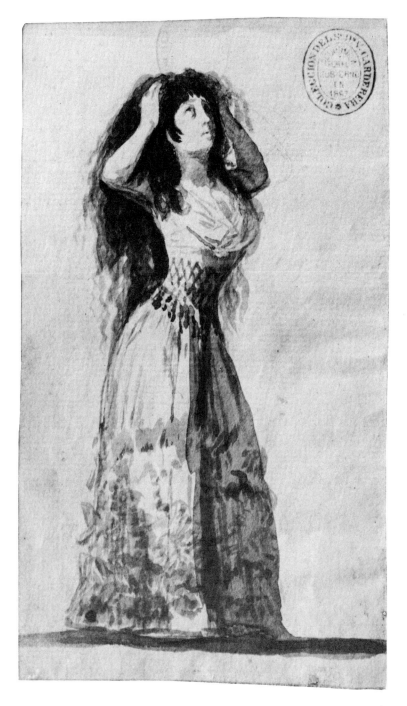

FIG. 7

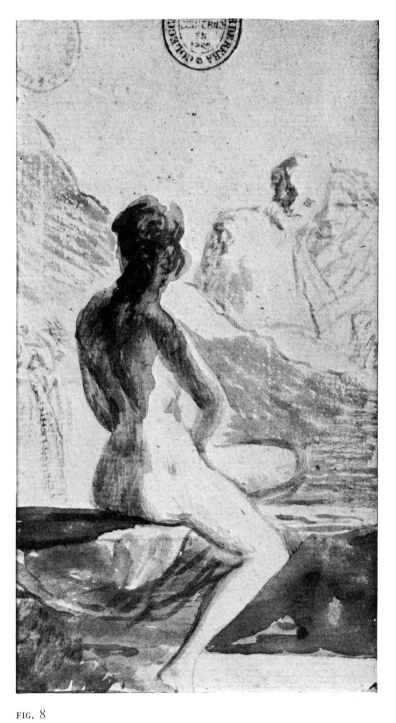

FIG. 8

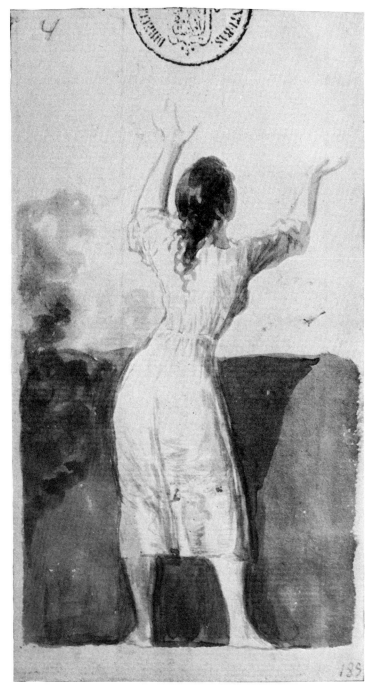

FIG. 9

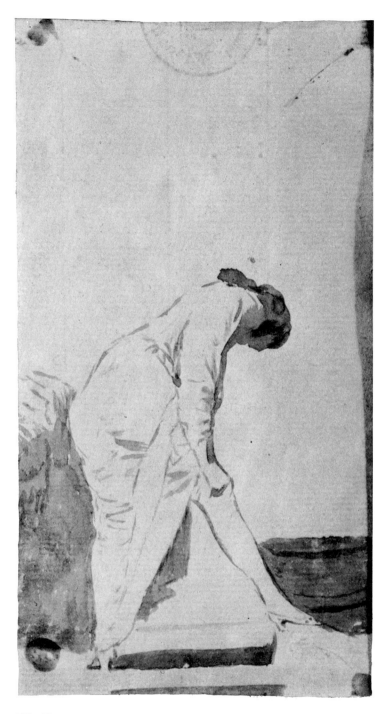

FIG. 10

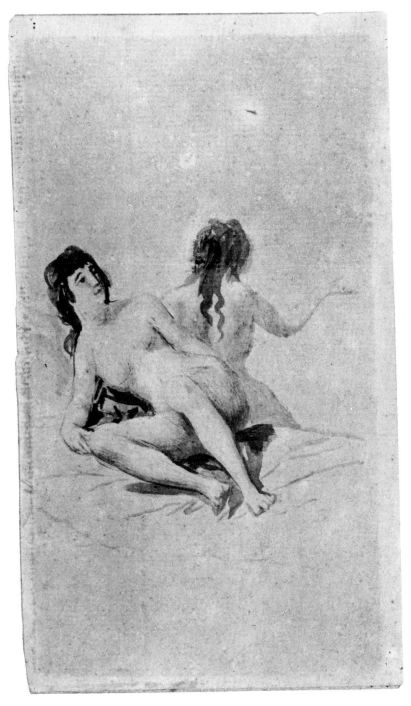

FIG. II

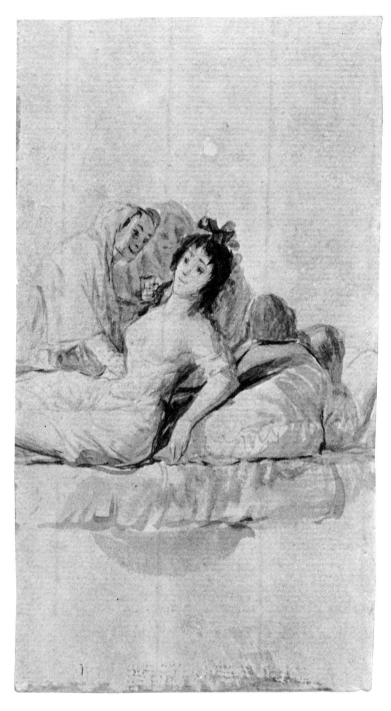

FIG. 12

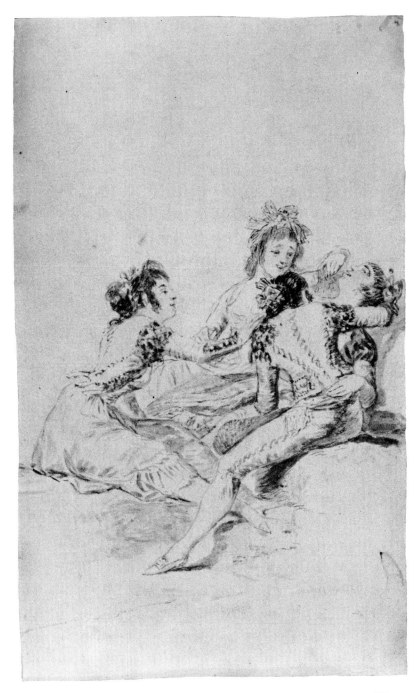

FIG. 13

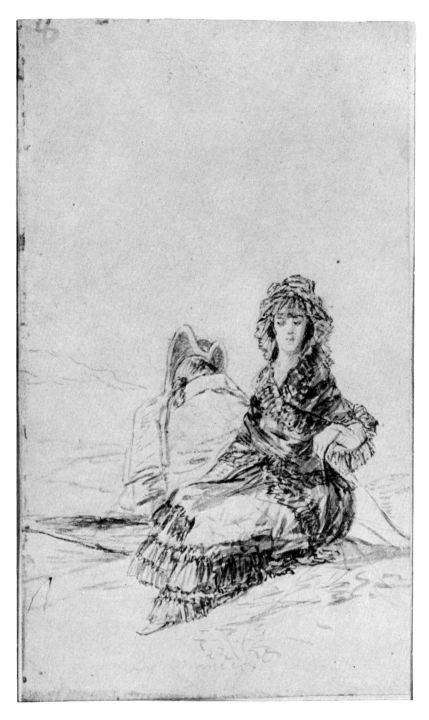

FIG. 14

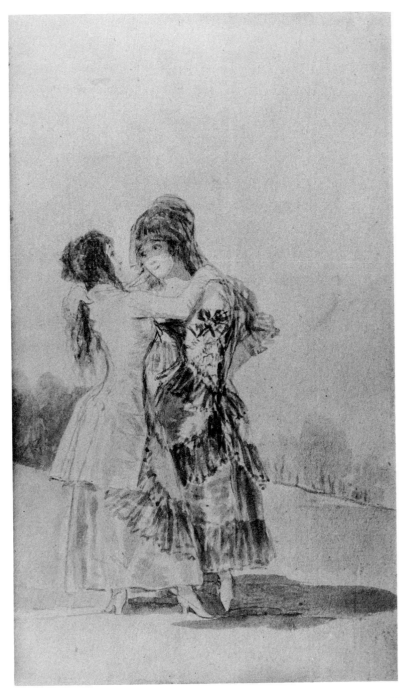

FIG. 15

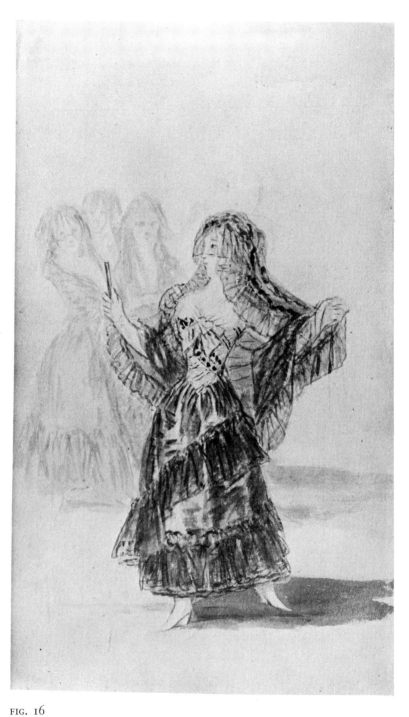

FIG. 16

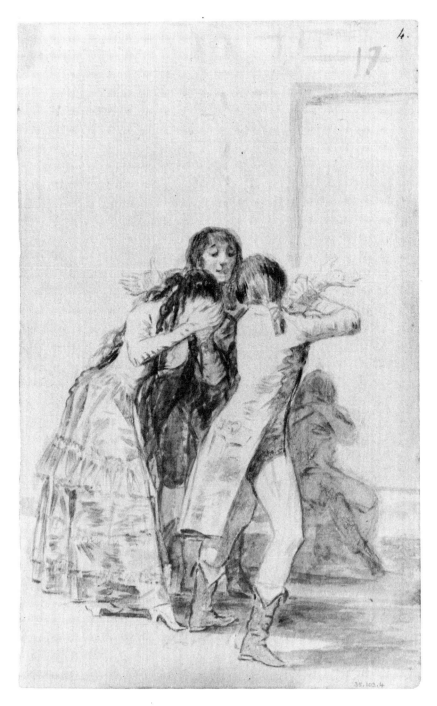

FIG. 17

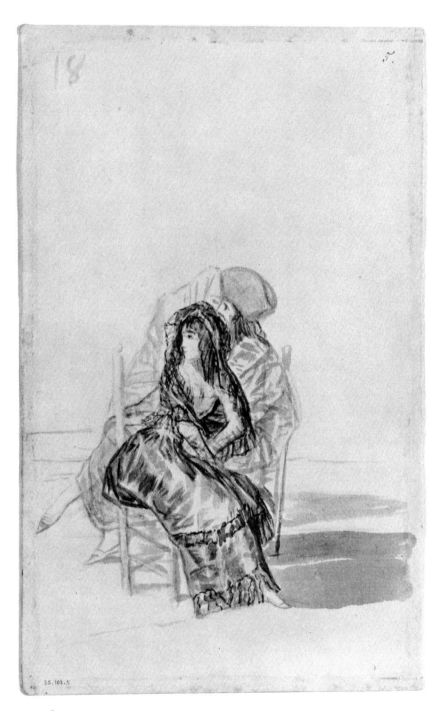

FIG. 18

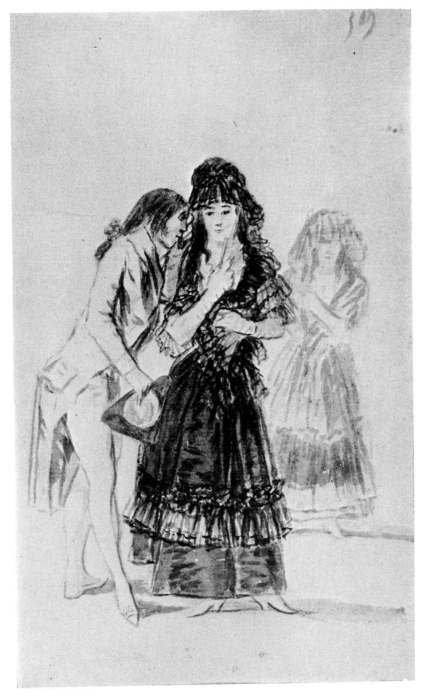

FIG. 19

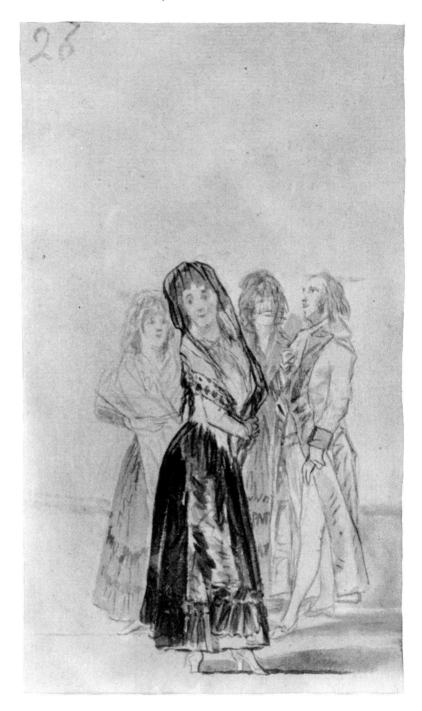

FIG. 20

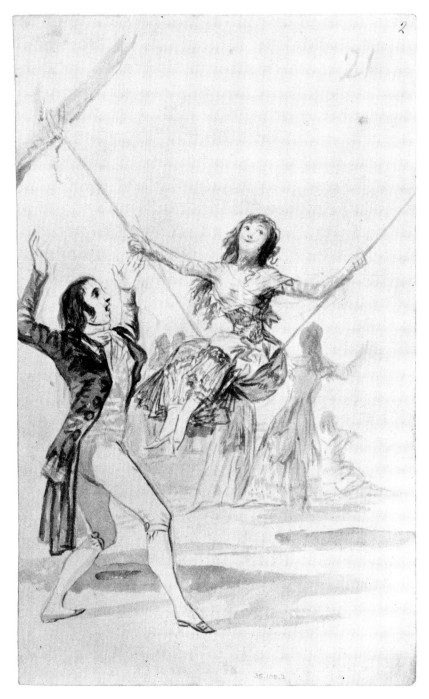

FIG. 21

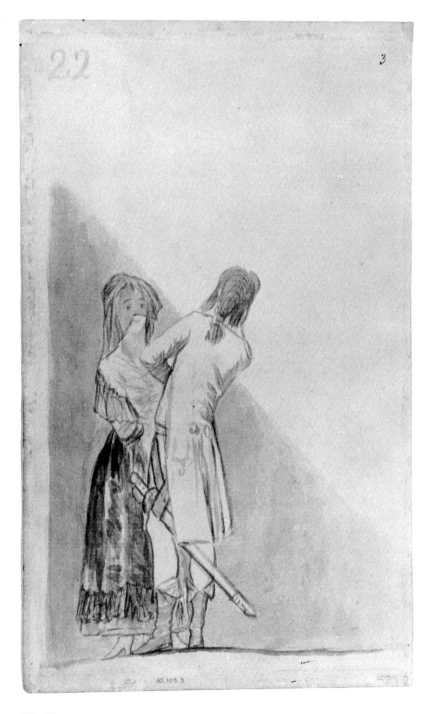

FIG. 22

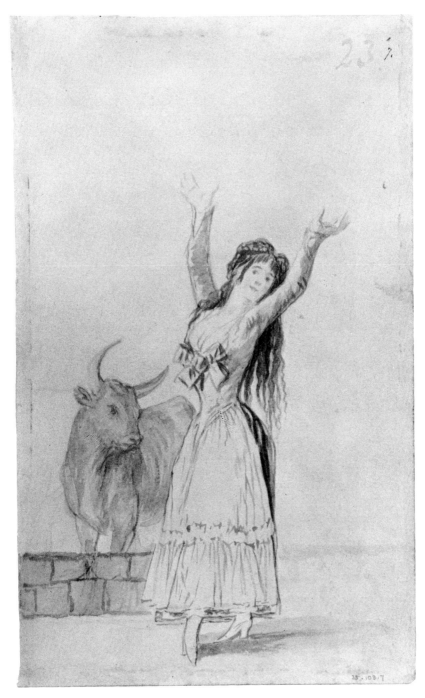

FIG. 23

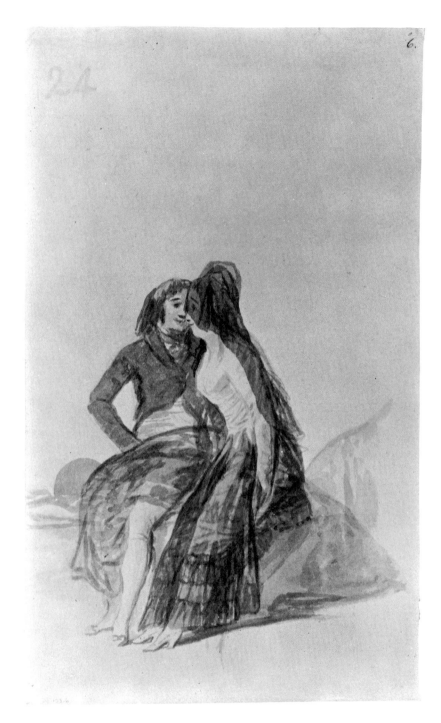

FIG. 24

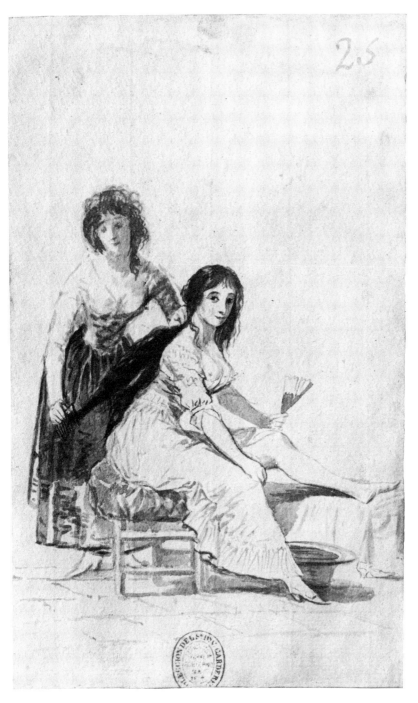

FIG. 25

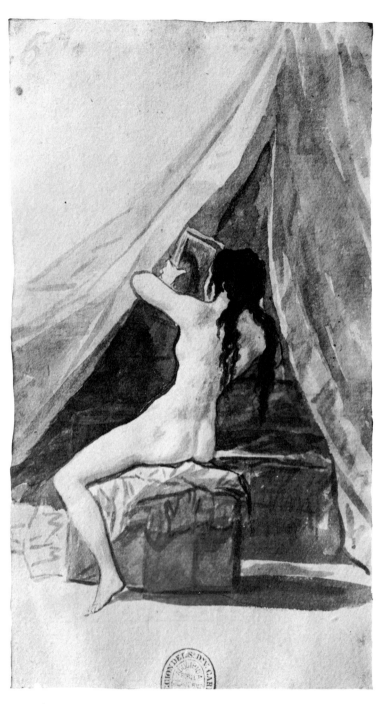

FIG. 26

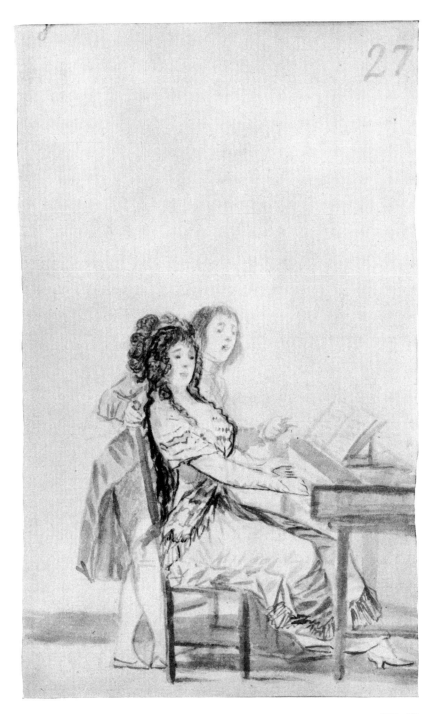

FIG. 27

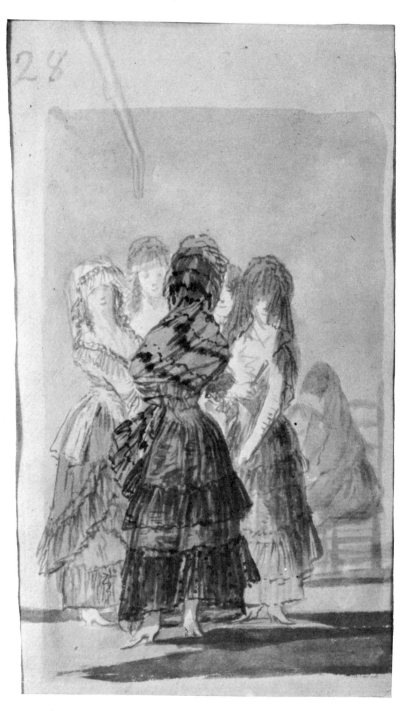

FIG. 28

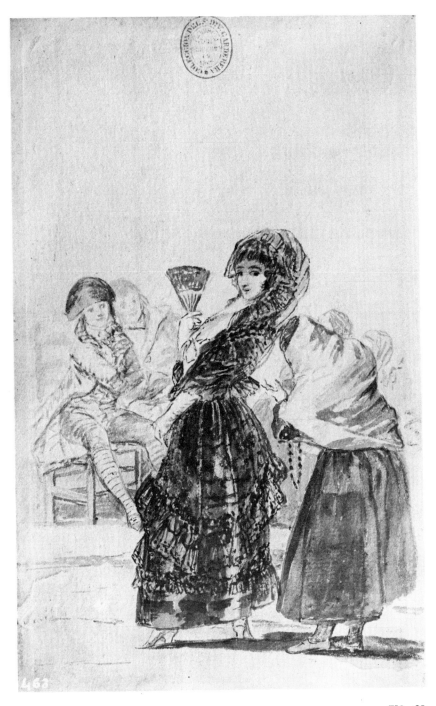

FIG. 29

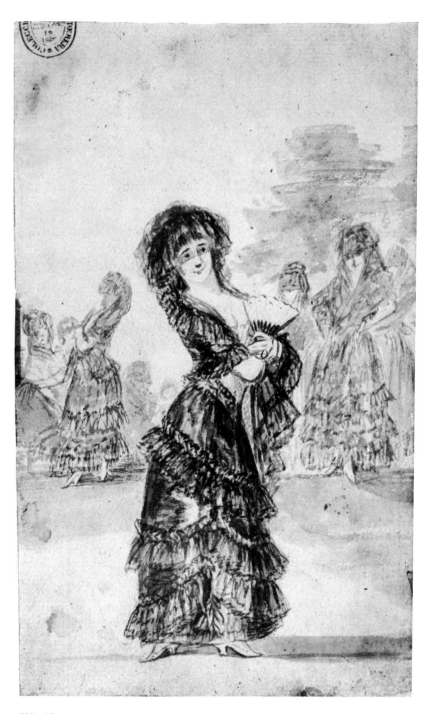

FIG. 30

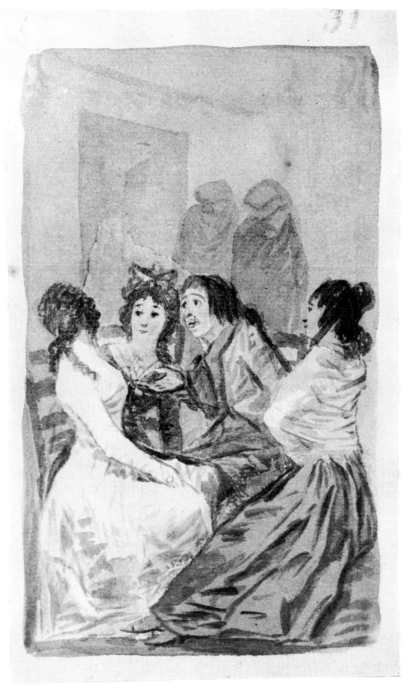

FIG. 31

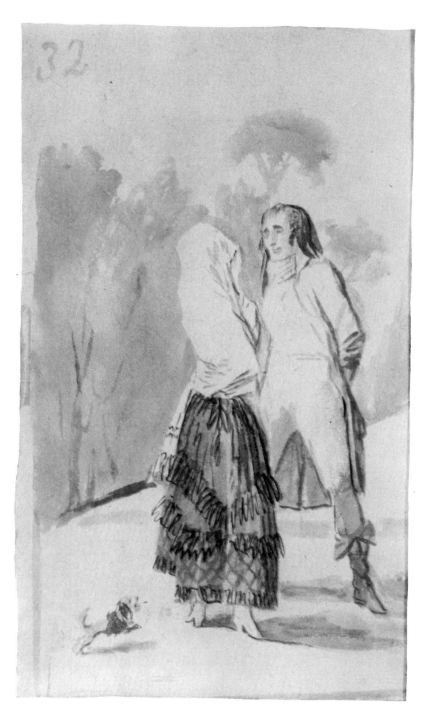

FIG. 32

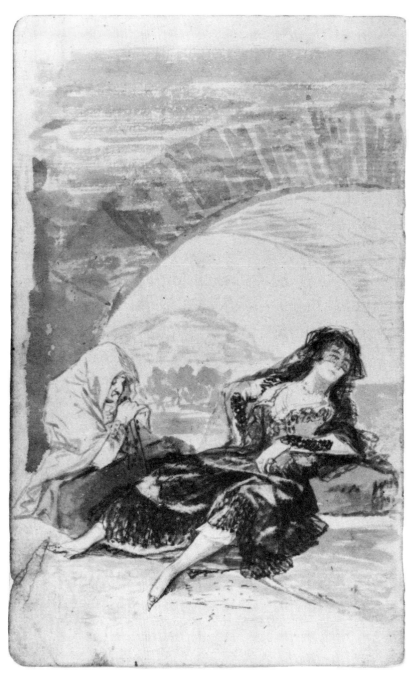

FIG. 33

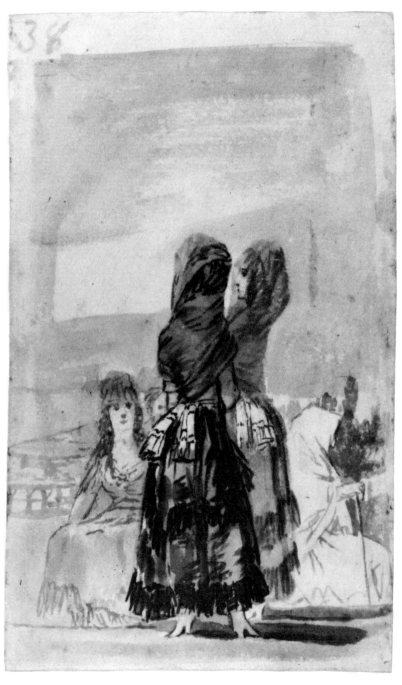

FIG. 34

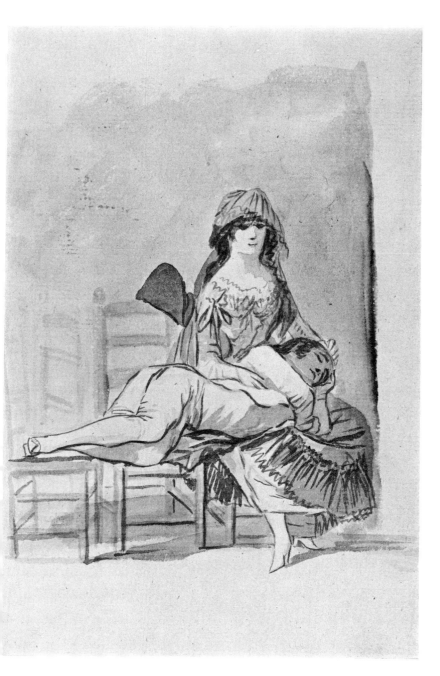

FIG. 35

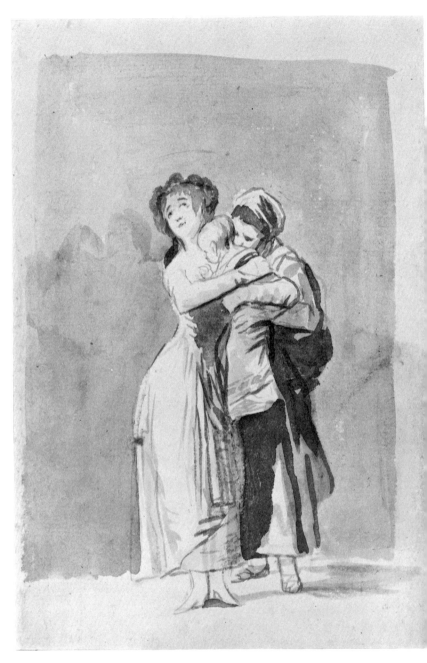

FIG. 36

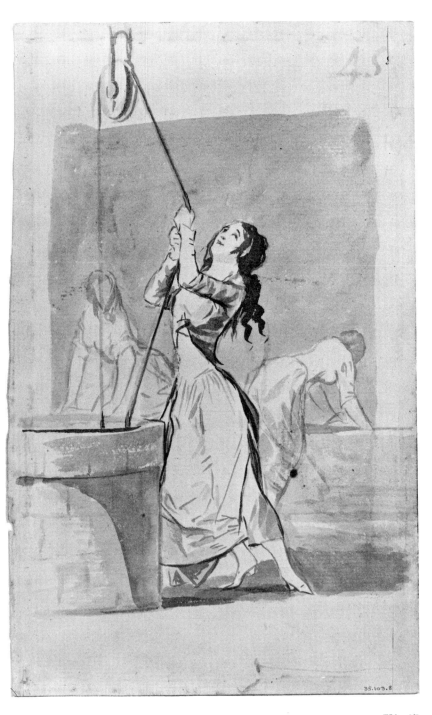

FIG. 37

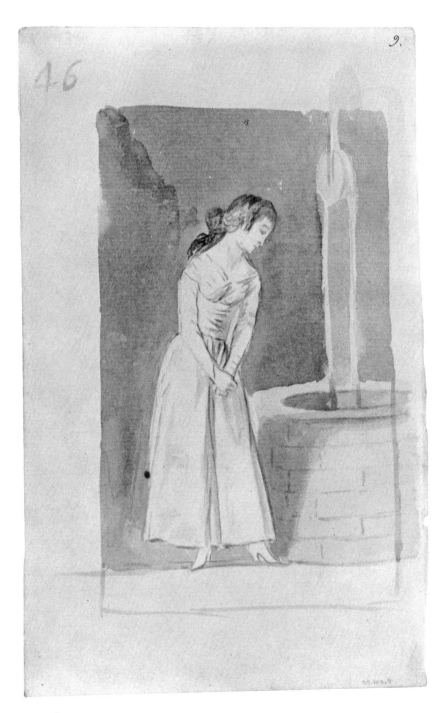

FIG. 38

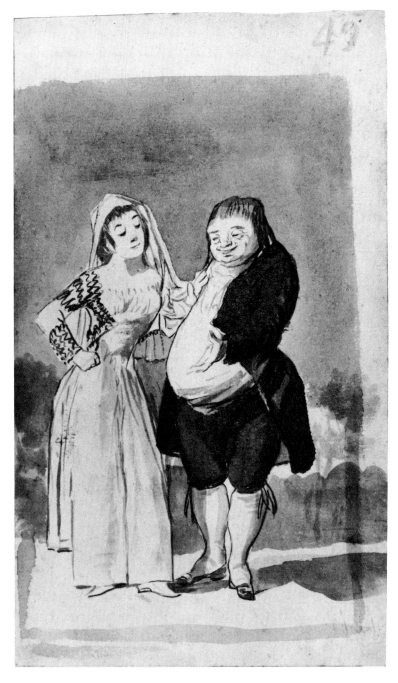

FIG. 39

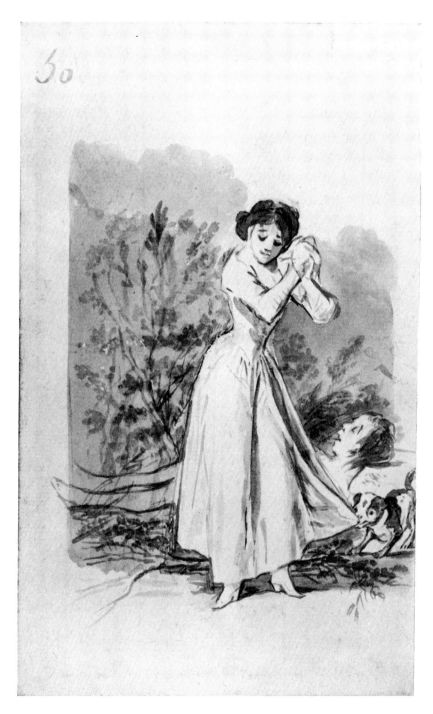

FIG. 40

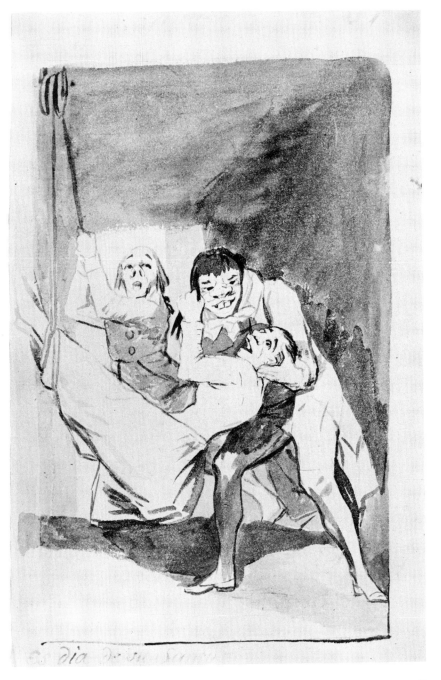

El dia de su santo

FIG. 41

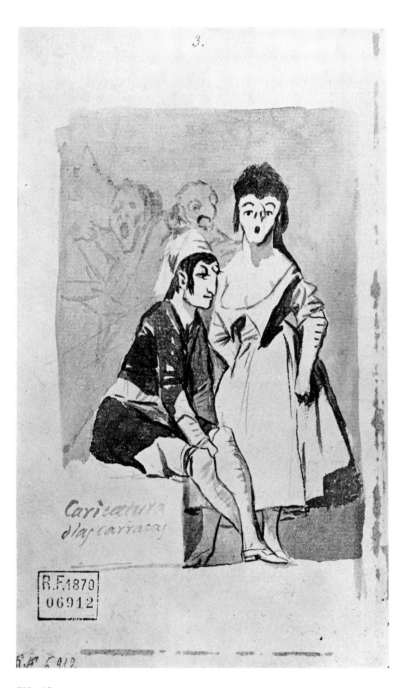

FIG. 42

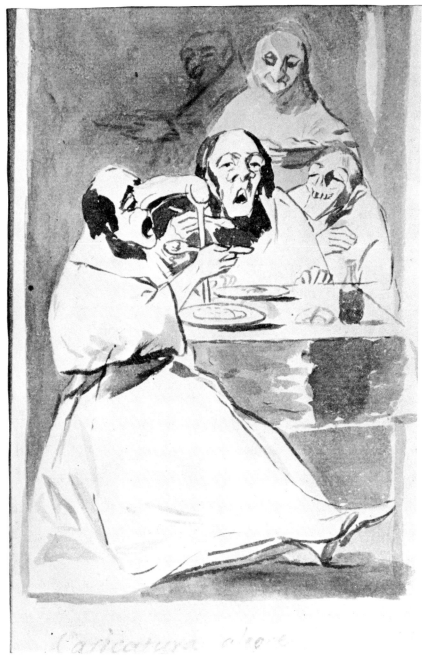

Caricatura alegre

FIG. 43

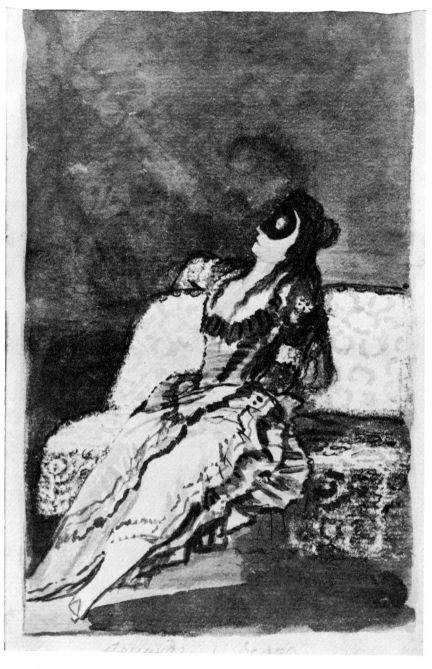

FIG. 44

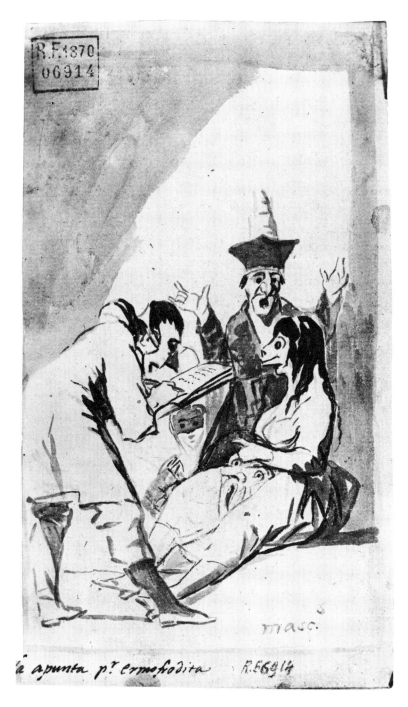

masc.

a apunta p.<sup>r</sup> ermofrodita    R.F6914

FIG. 45

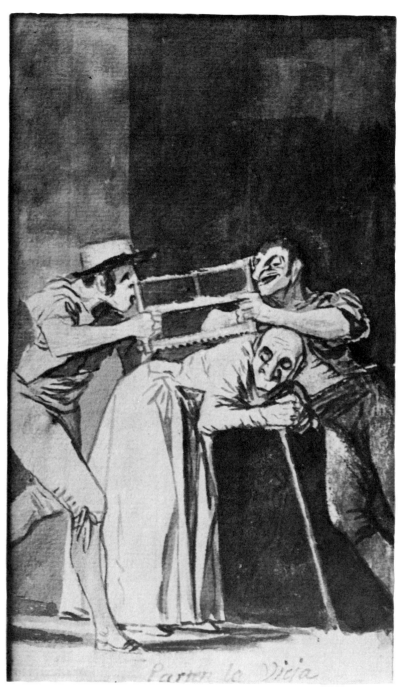

FIG. 46

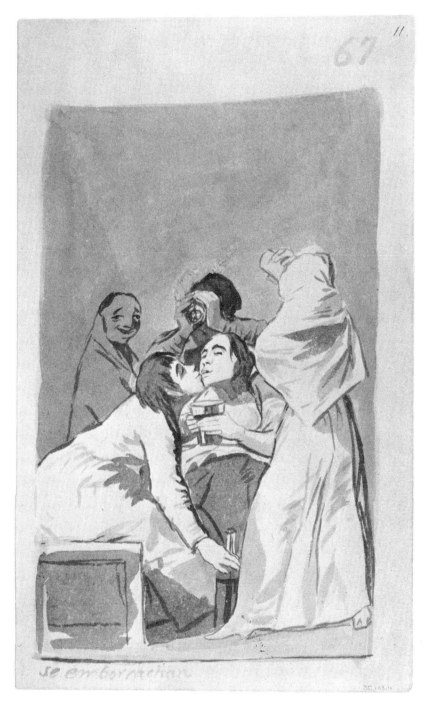

FIG. 47

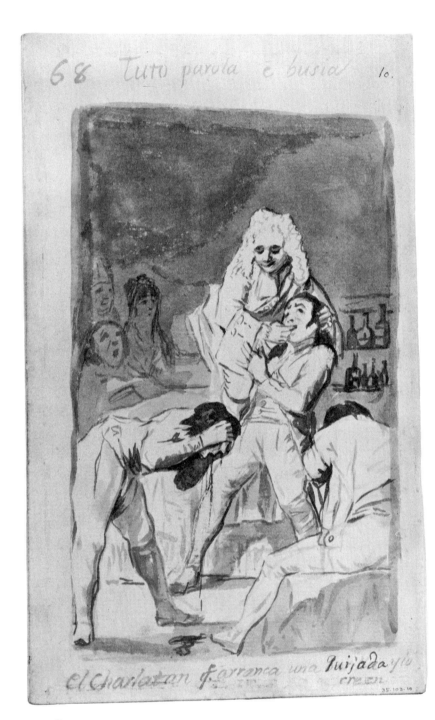

FIG. 48

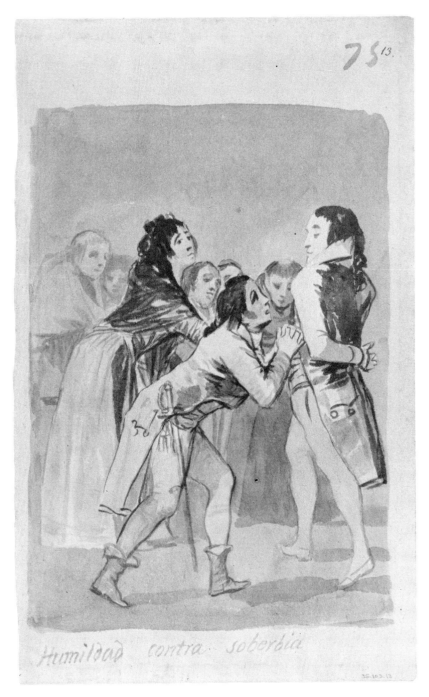

*Humildad contra soberbia*

FIG. 49

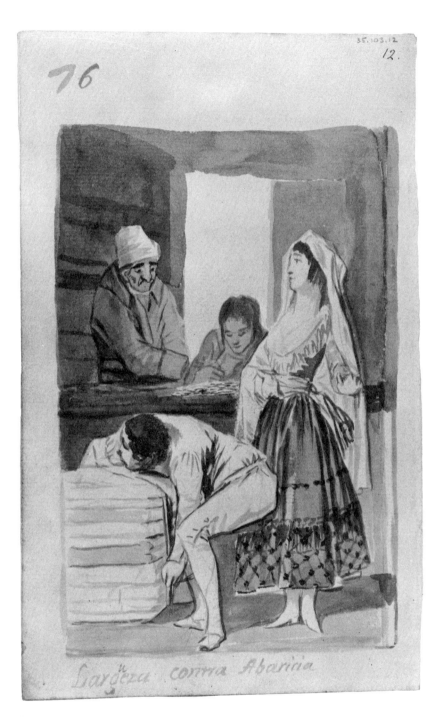

Lardeza contra Abaricia

FIG. 50

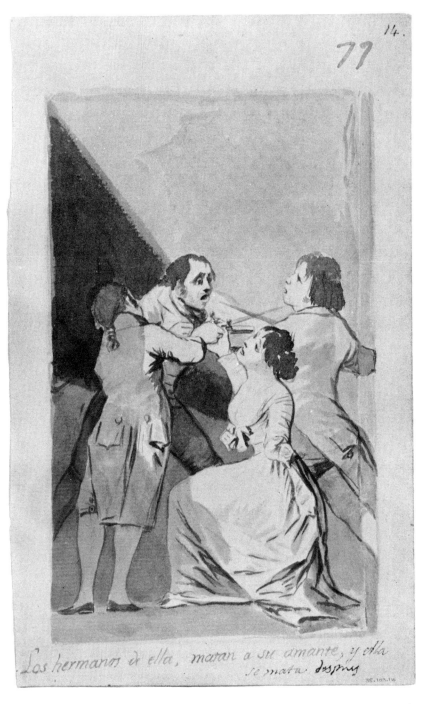

Los hermanos de ella, matan a su amante, y ella se mata despues.

FIG. 51

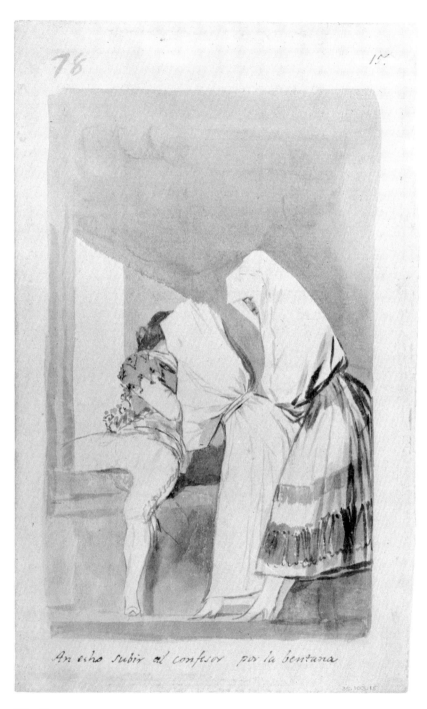

An echo subir al confesor por la bentana

FIG. 52

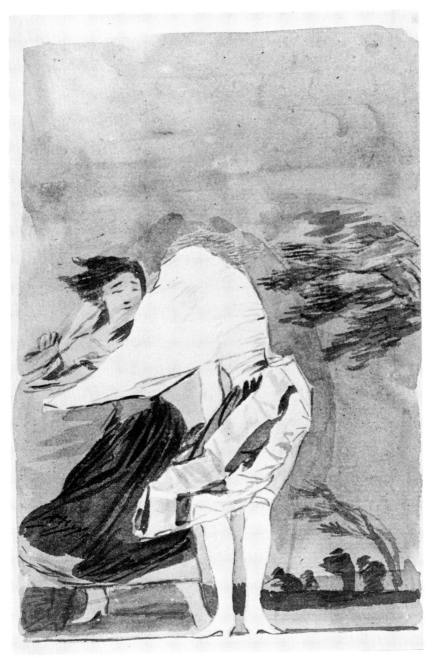

FIG. 53

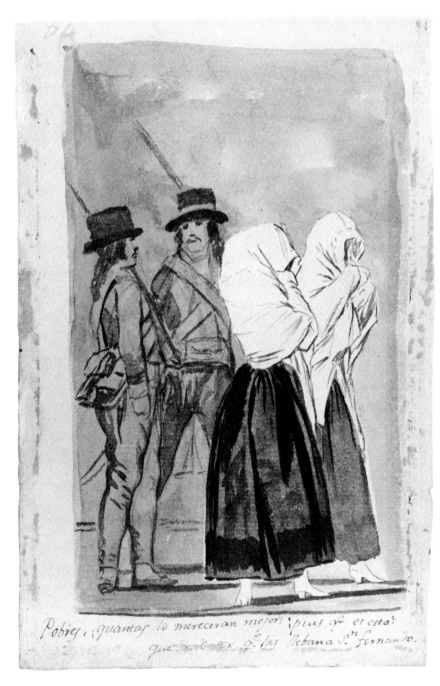

Pobres, ¡quantas lo mereceran mejor! ¿pues q.<sup>e</sup> es esto?
que a...... R.l...... las tebana S.<sup>n</sup> fernando.

FIG. 54

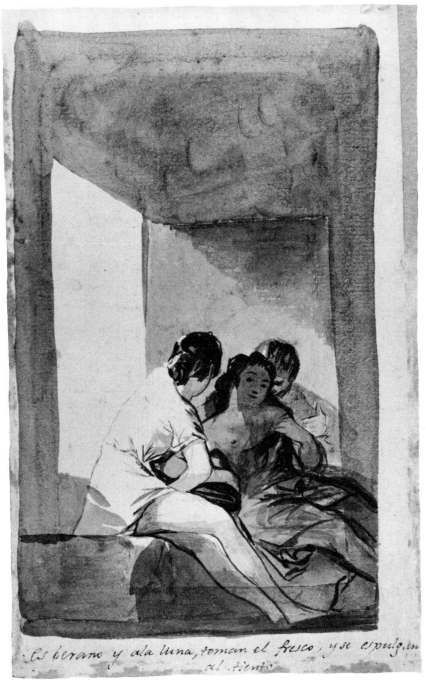

Es berano y ala luna, toman el fresco, y se espulgan
al tiento

FIG. 55

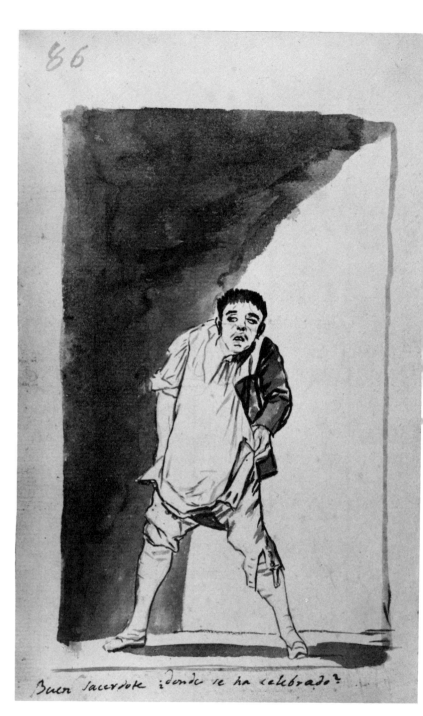

Buen Sacerdote ¿donde se ha celebrado?

FIG. 56

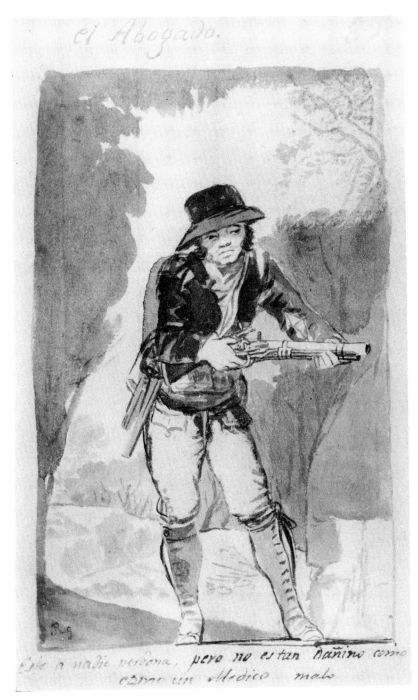

*el Abogado.*

*Este a nadie perdona, pero no estan dañino como estar un Medico malo*

FIG. 57

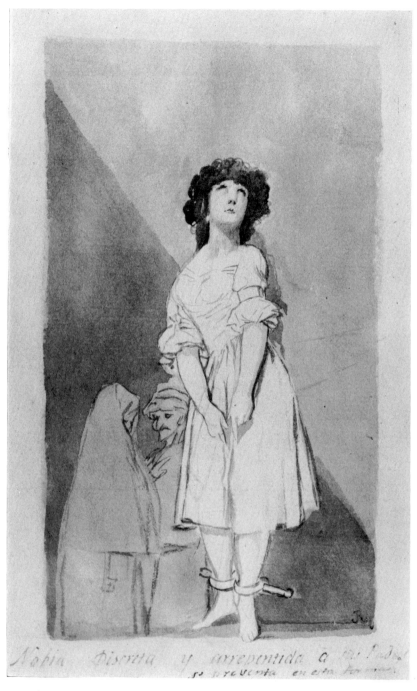

Nobia disreta y arrepentida a ... 
se presenta en esta forma

FIG. 58

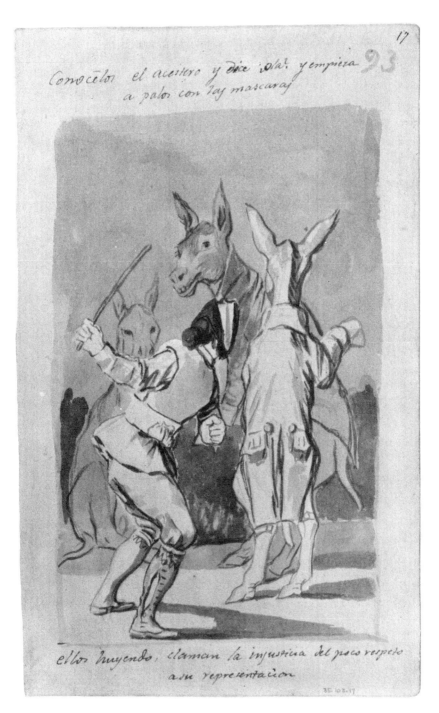

FIG. 59

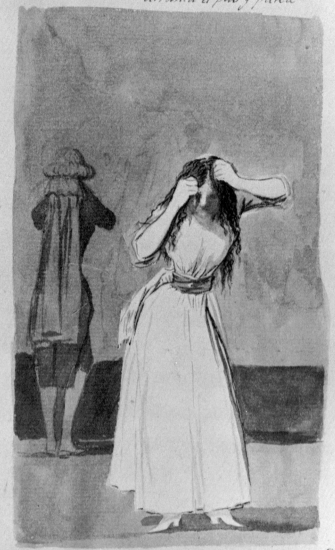

Manda q quiten el coche, se despeina, y
arranca el pelo y patéa

Porq. el abate Pichurris, le á dicho en su ocico, q.
estaba descolorida

FIG. 60

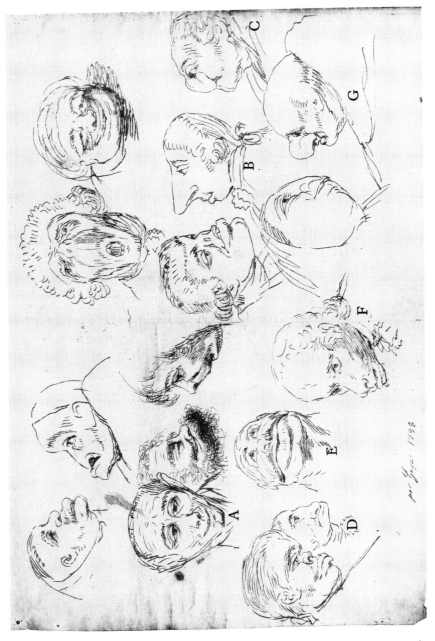

FIG. 61

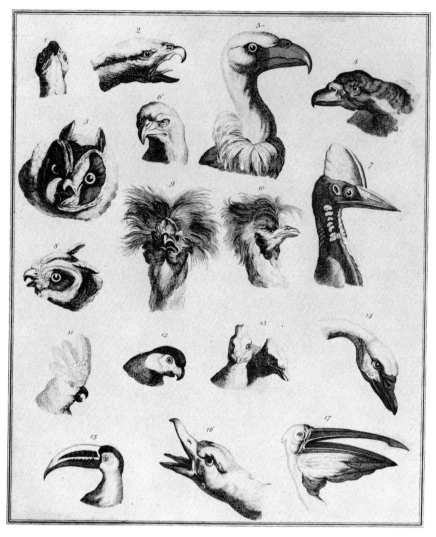

FIG. 62

2

FIG. 63

 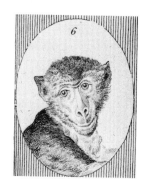

FIG. 64

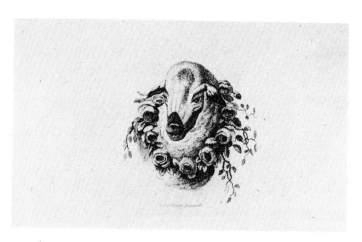

FIG. 65

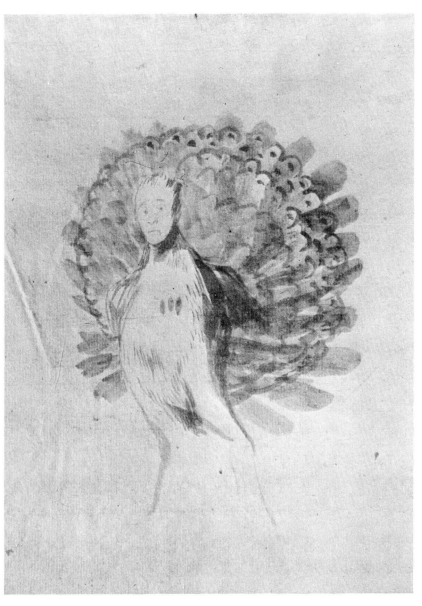

FIG. 66

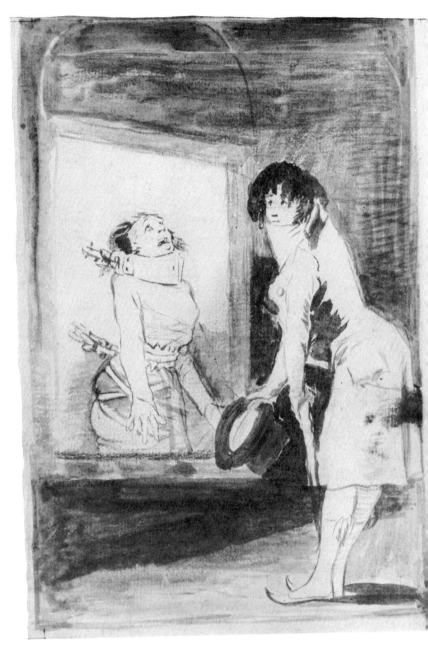

FIG. 67

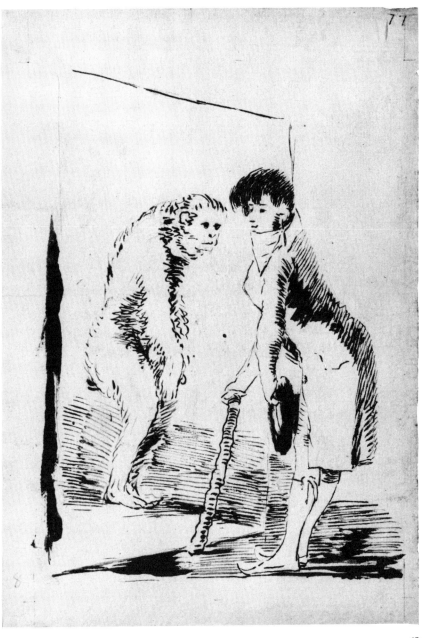

FIG. 68

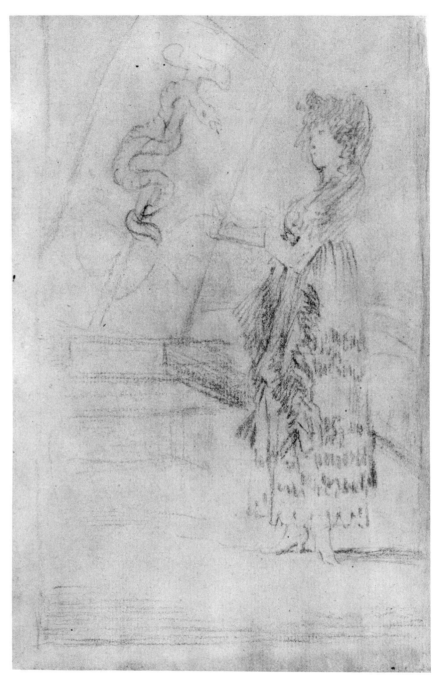

FIG. 69

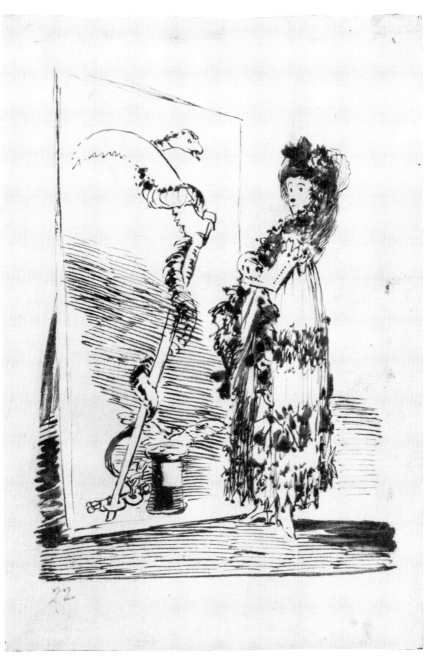

FIG. 70

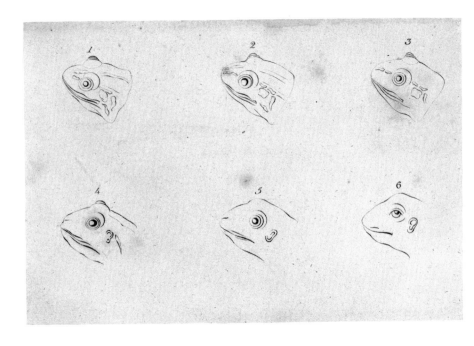

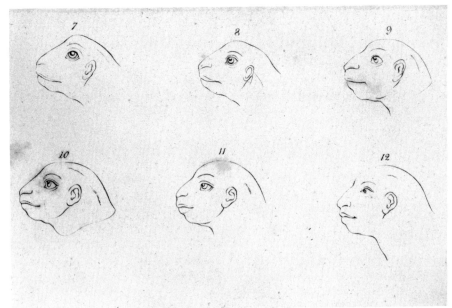

FIG. 71

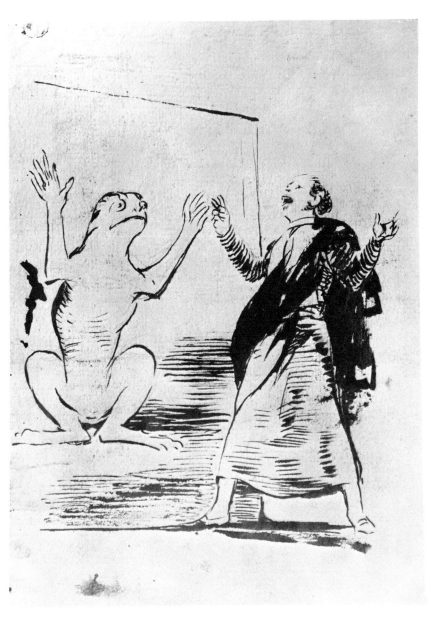

FIG. 72

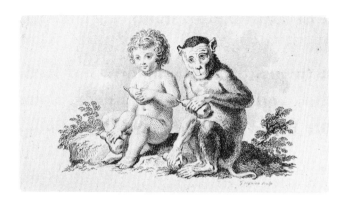

FIG. 73

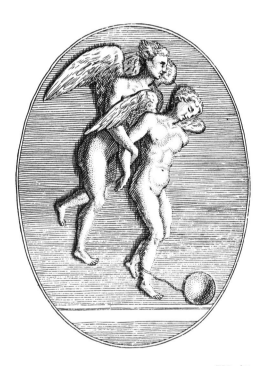

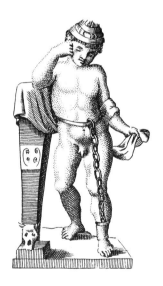

FIG. 74

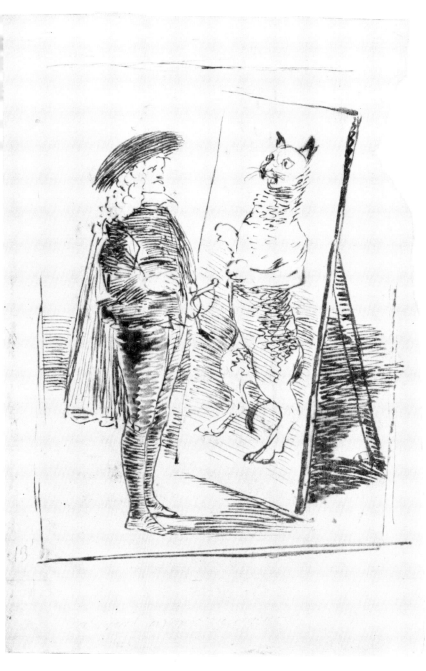

FIG. 75

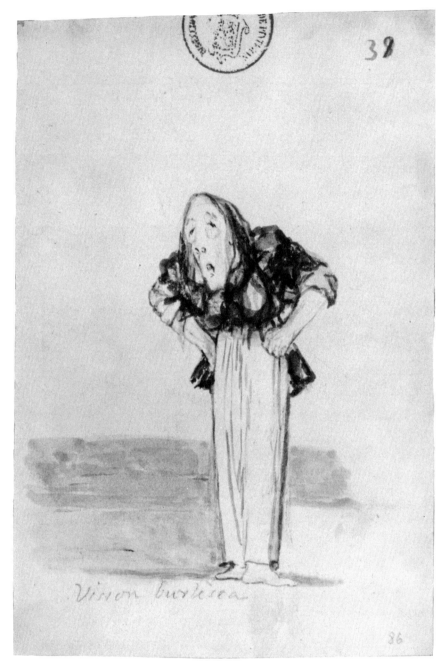

39

Vision burlesca

86

FIG. 76

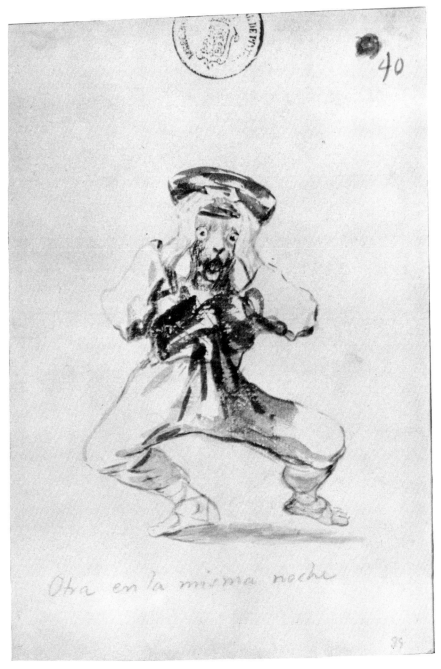

40

Otra en la misma noche

FIG. 77

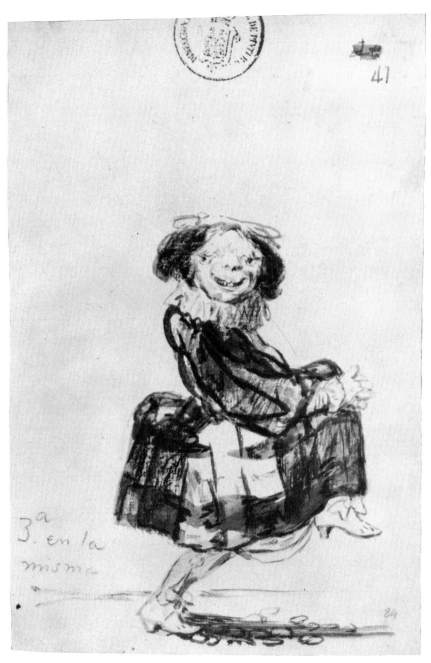

FIG. 78

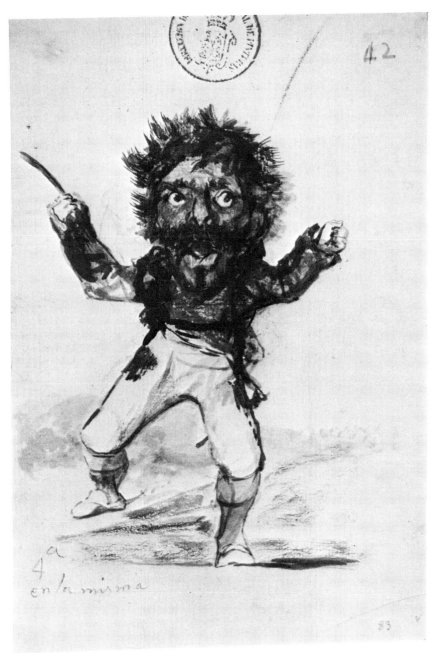

FIG. 79

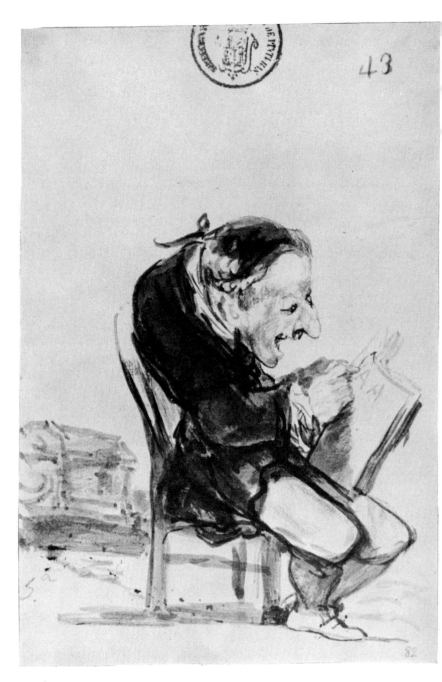

FIG. 80

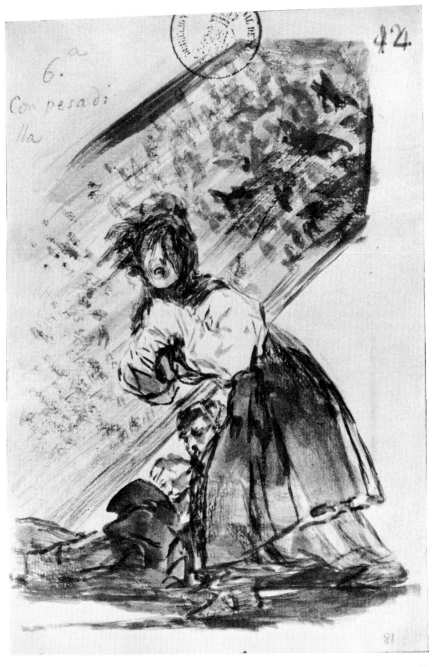

FIG. 81

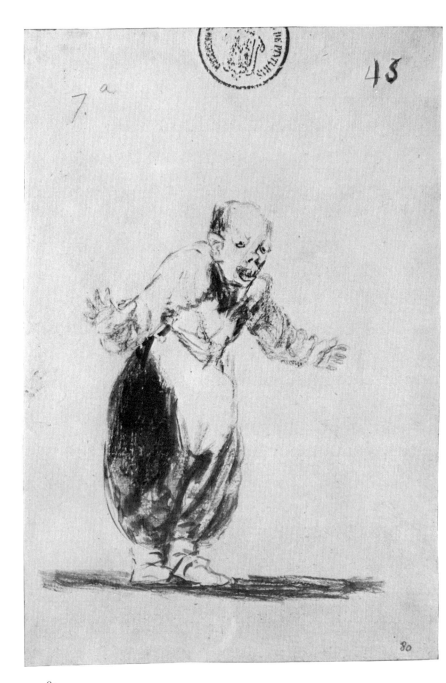

FIG. 82

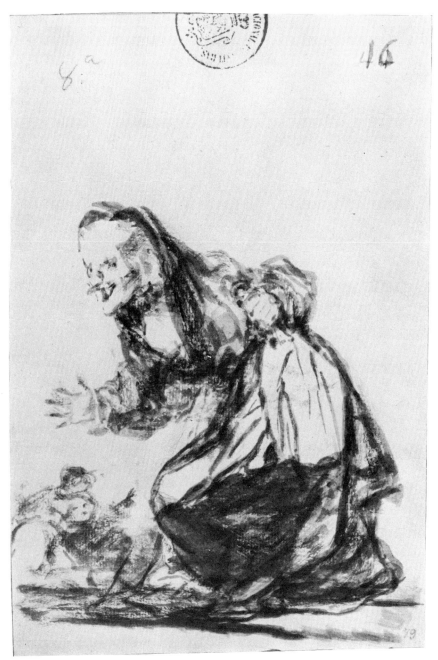

FIG. 83

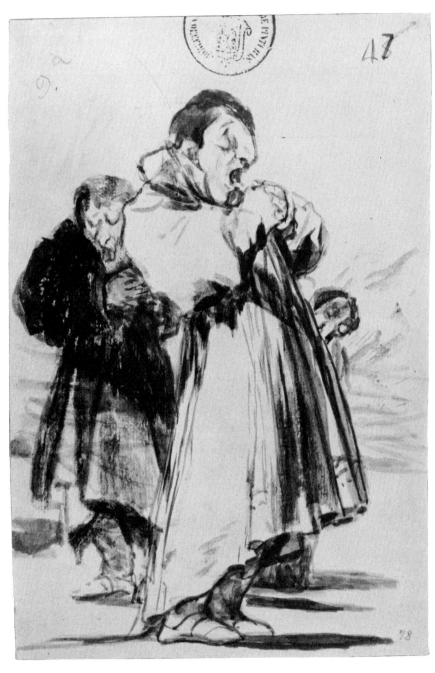

FIG. 84

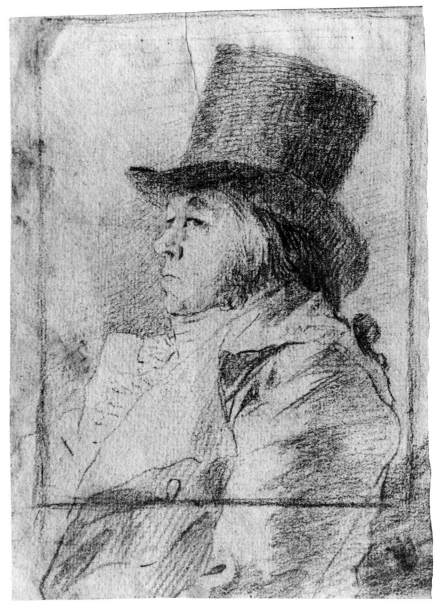

FIG. 85

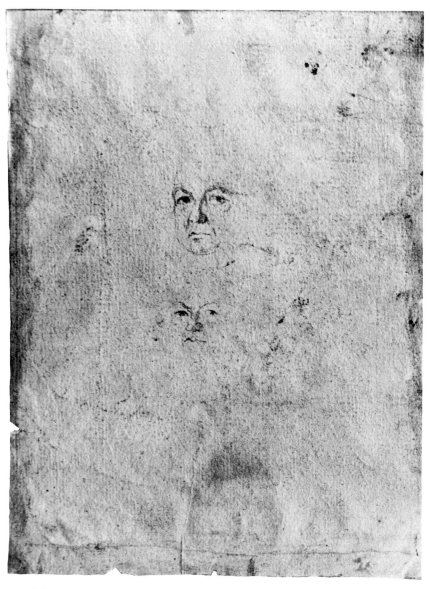

FIG. 86

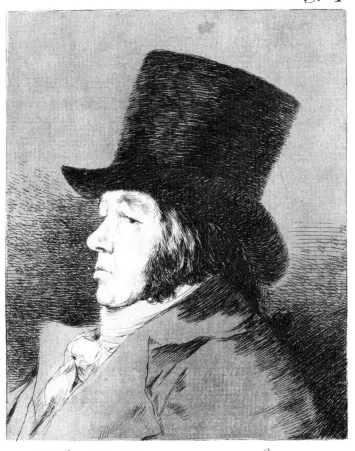

Fran.co Goya y Lucientes
Pintor.

FIG. 87

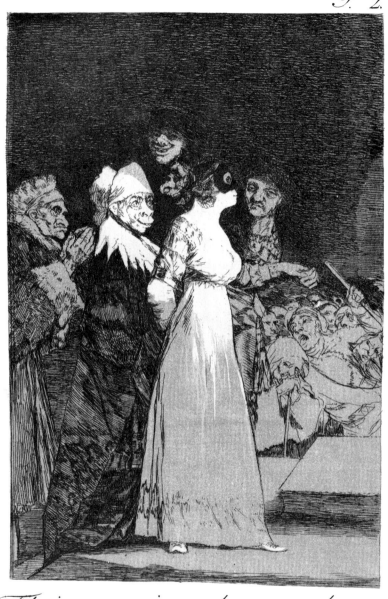

El si pronuncian y la mano alargan
Al primero que llega.

FIG. 88

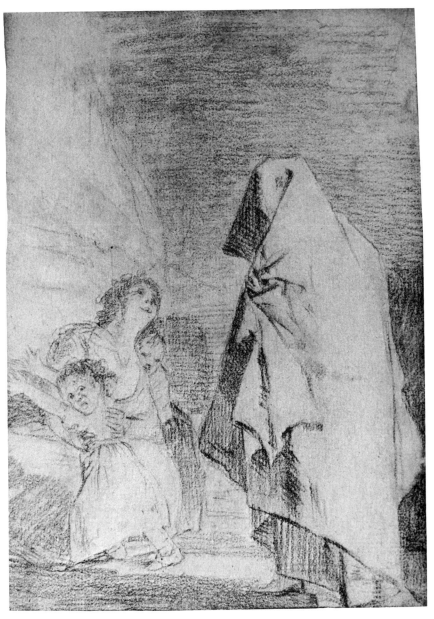

FIG. 89

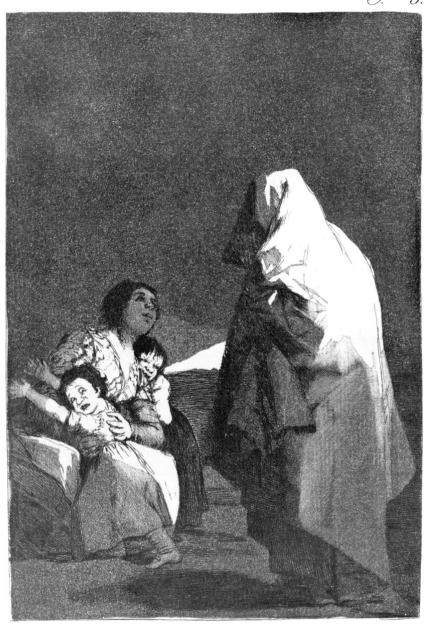

*Que biene el Coco.*

FIG. 90

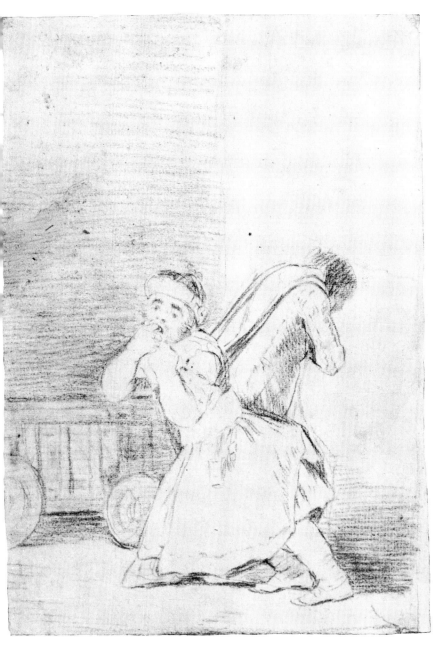

FIG. 91

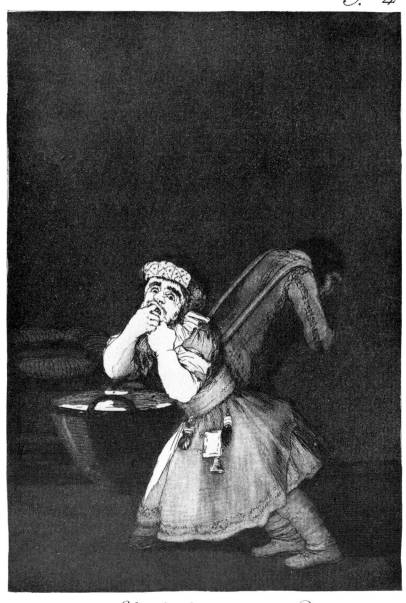

*El de la royona.*

FIG. 92

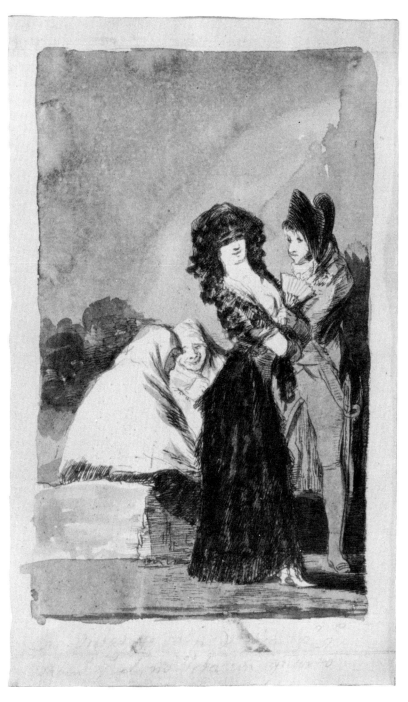

FIG. 93

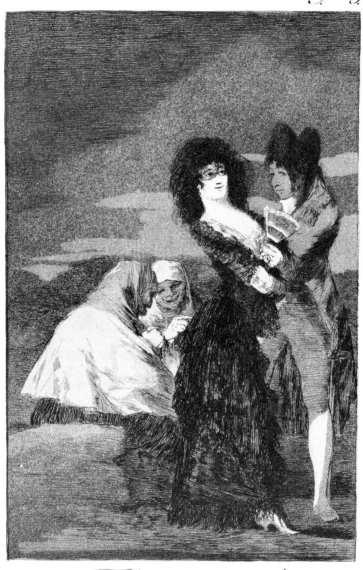

*Tal para qual.*

FIG. 94

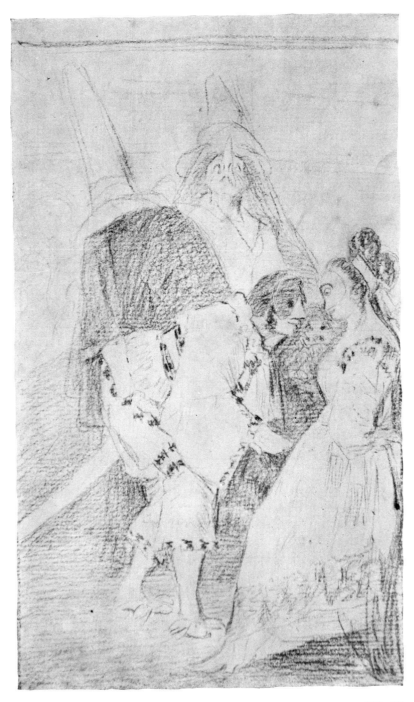

FIG. 95

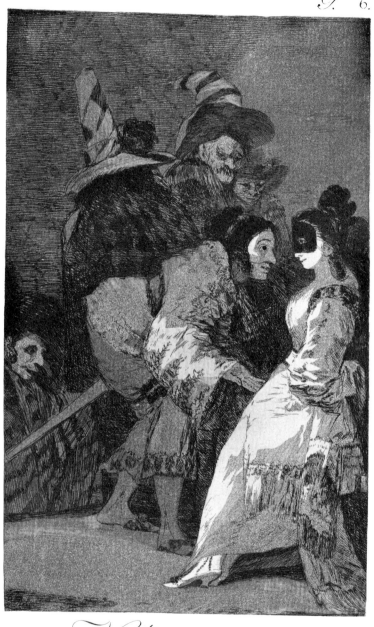

*Nadie se conoce.*

FIG. 96

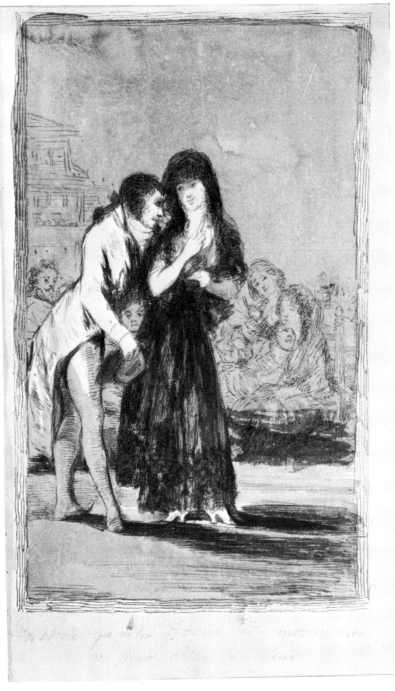

FIG. 97

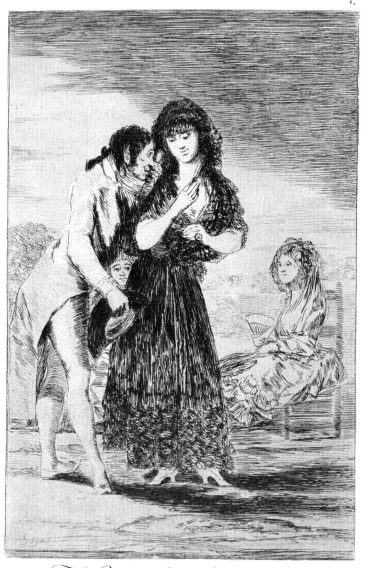

*Ni asi la distingue.*

FIG. 98

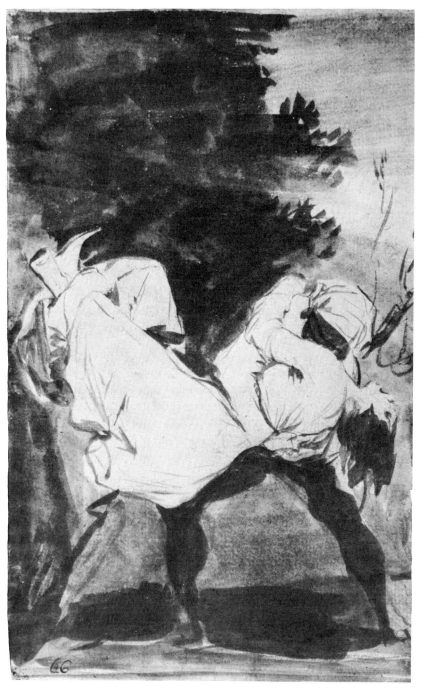

FIG. 99

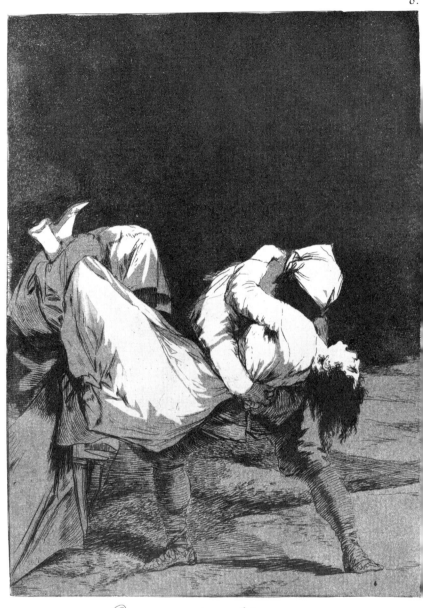

*Que se la llevaron.*

FIG. 100

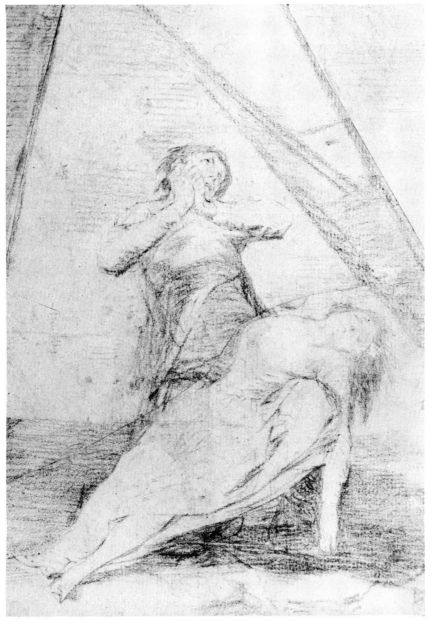

FIG. 101

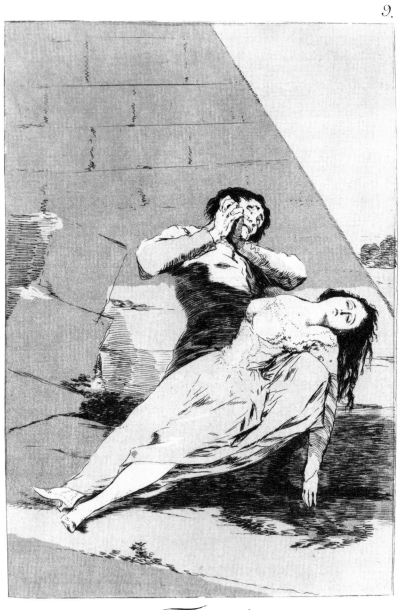

*Tantalo.*

FIG. 102

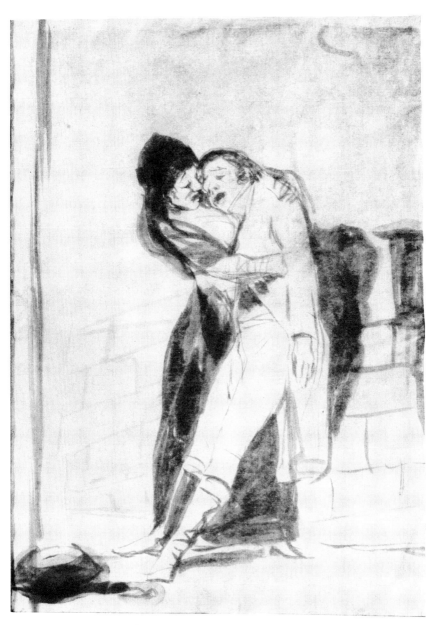

FIG. 103

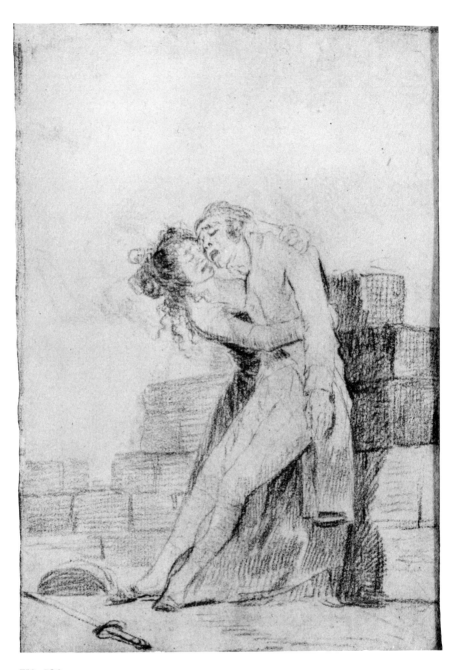

FIG. 104

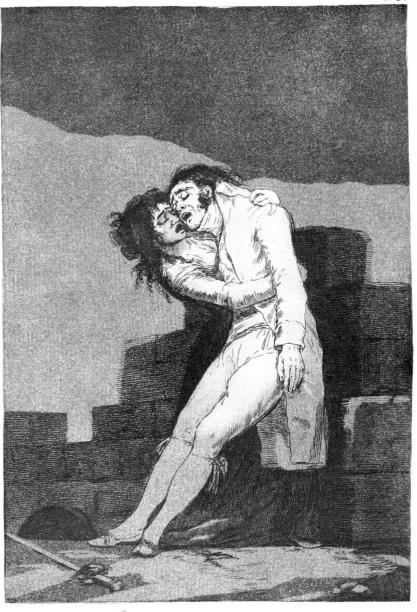

*El amor y la muerte.*

FIG. 105

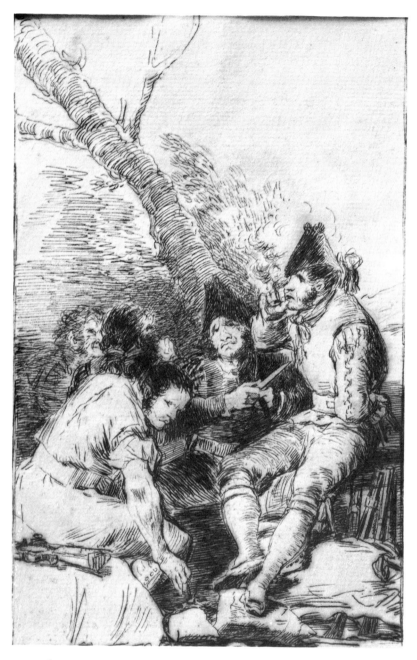

FIG. 106

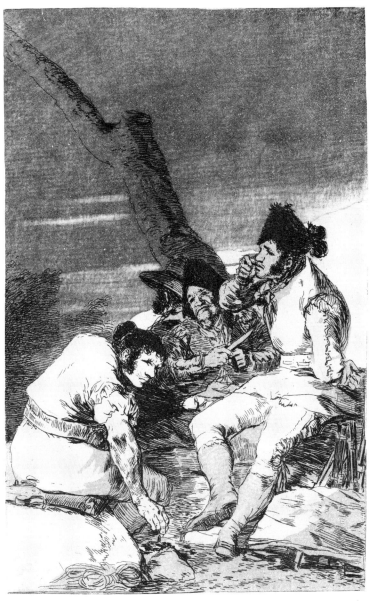

*Muchachos al avío.*

FIG. 107

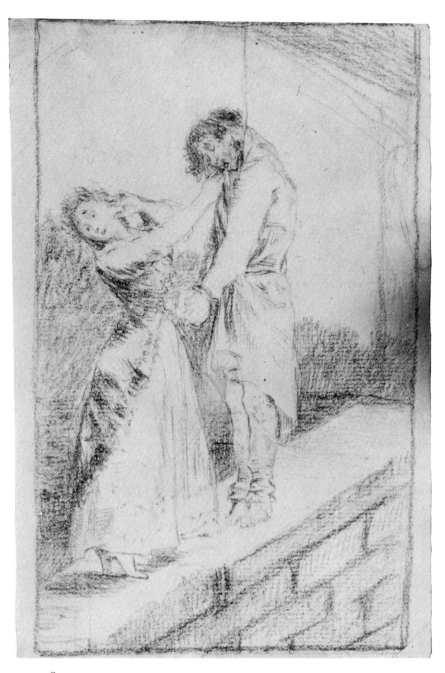

FIG. 108

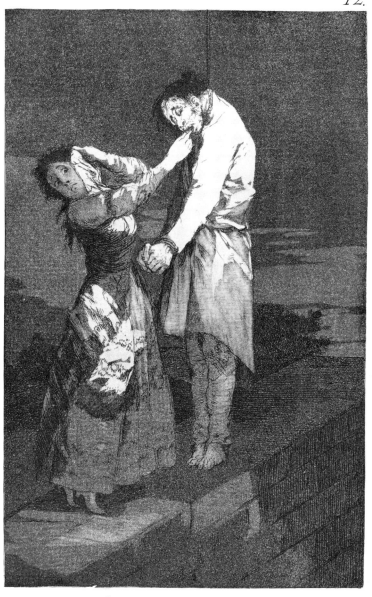

*A caza de dientes.*

FIG. 109

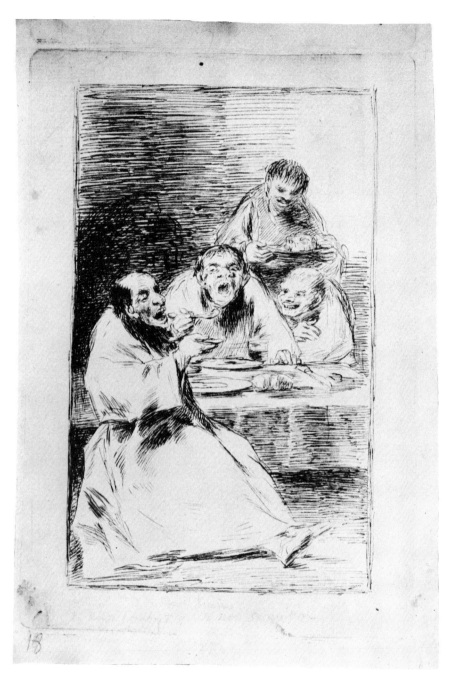

FIG. 110

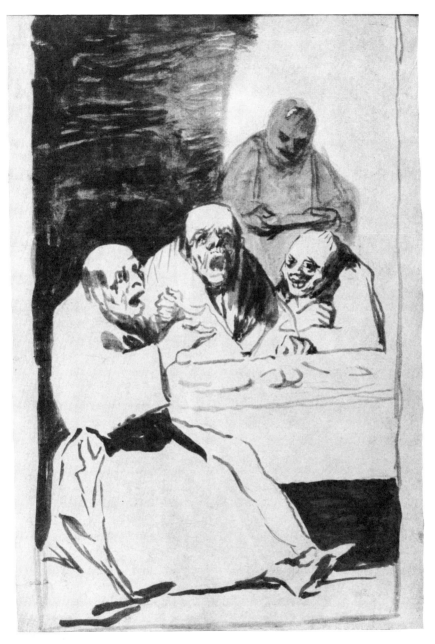

FIG. III

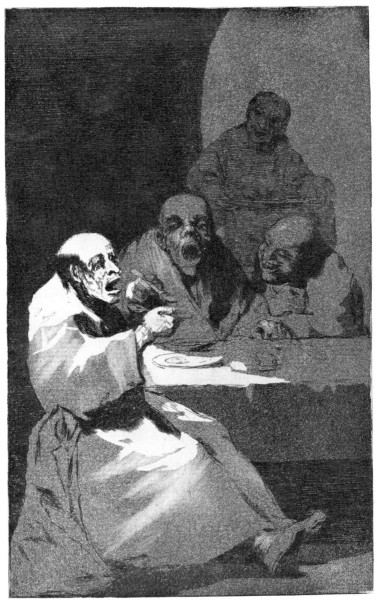

*Estan calientes.*

FIG. 112

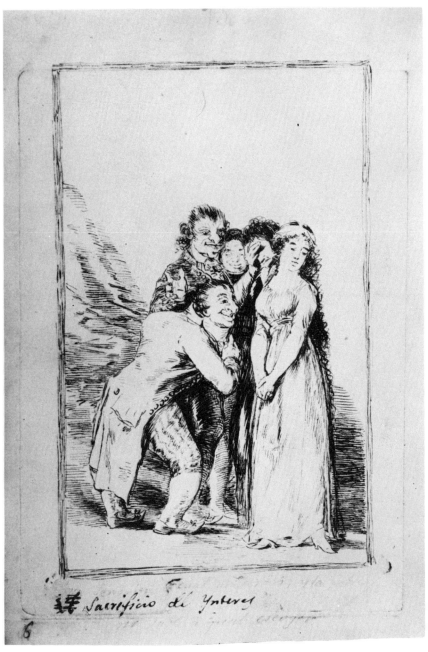

Sacrificio de Ynteres

FIG. 113

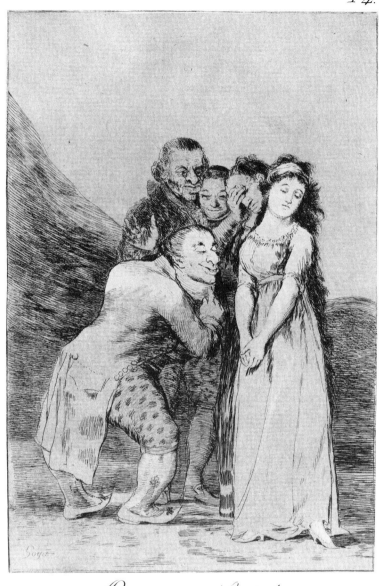

*Que sacrificio!*

FIG. 114

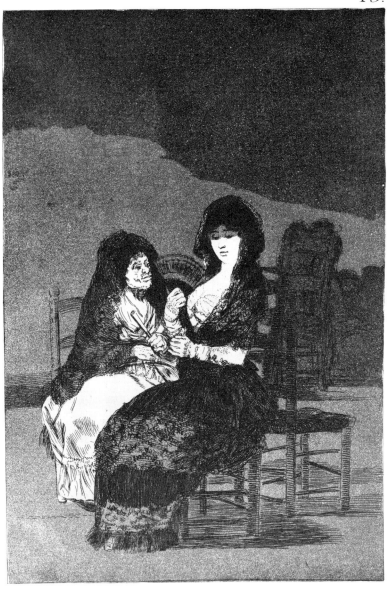

*Bellos consejos.*

FIG. 115

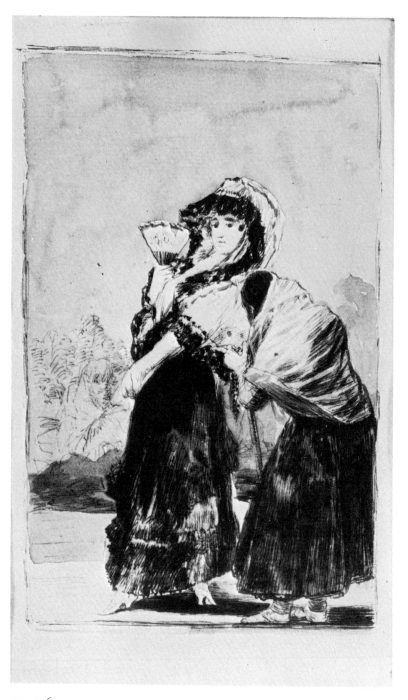

FIG. 116

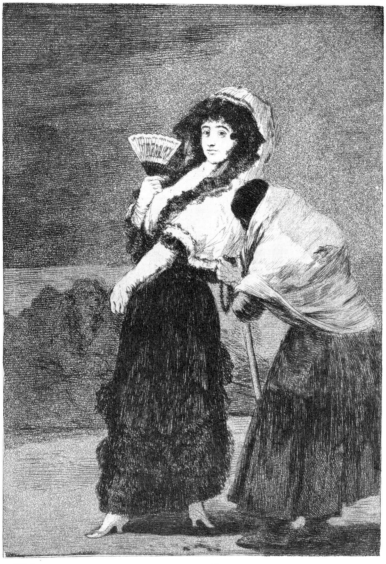

*Dios la perdone: Y era su madre.*

FIG. 117

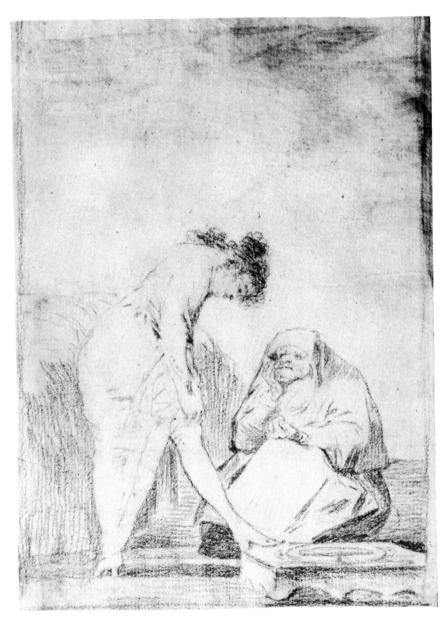

FIG. 118

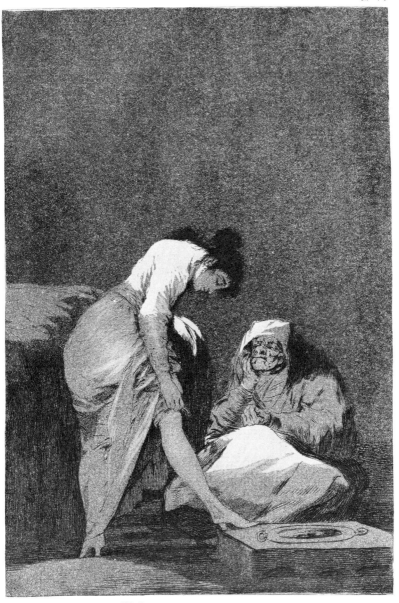

*Bien tirada está.*

FIG. 119

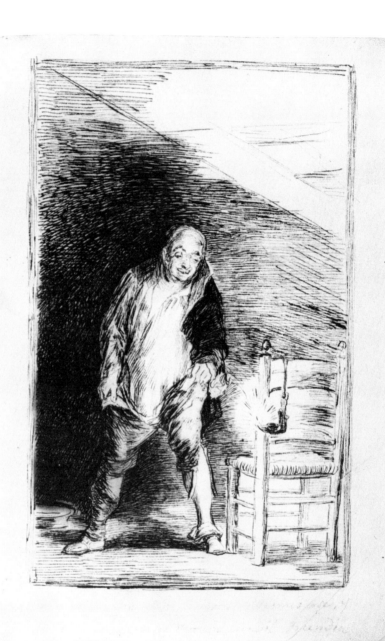

FIG. 120

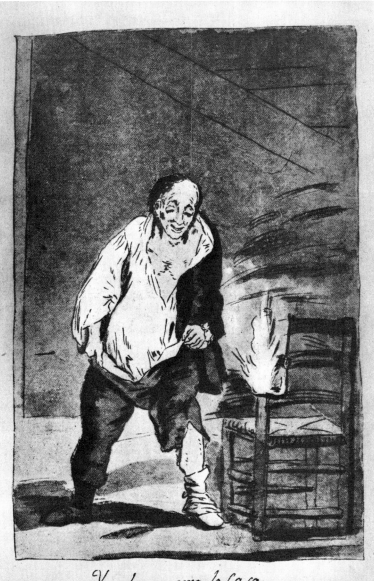

Yse le quema la Casa

FIG. 121

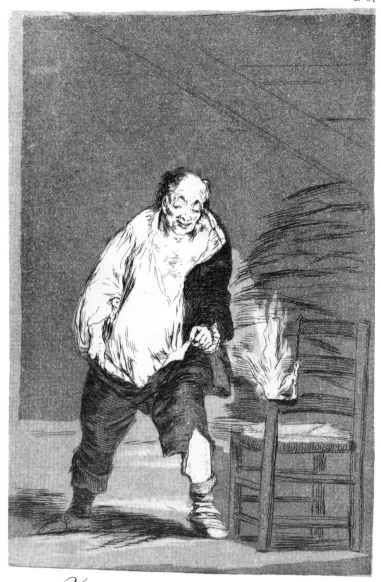

*Ysele quema la Casa).*

FIG. 122

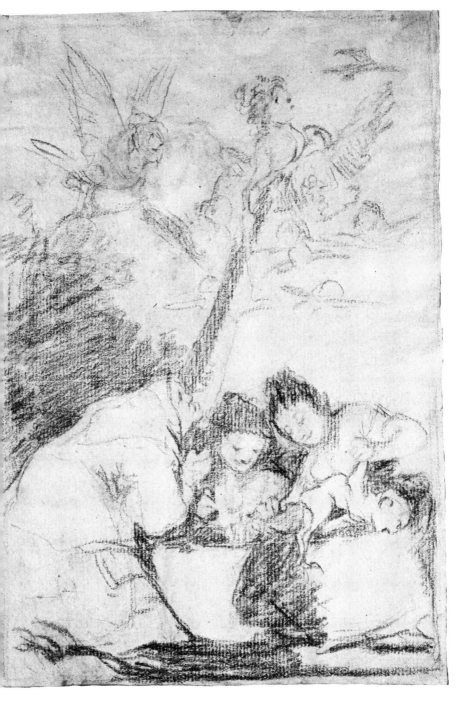

FIG. 123

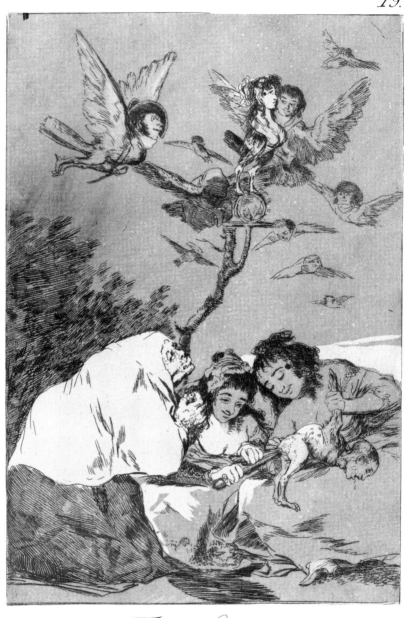

*Todos Caerán.*

FIG. 124

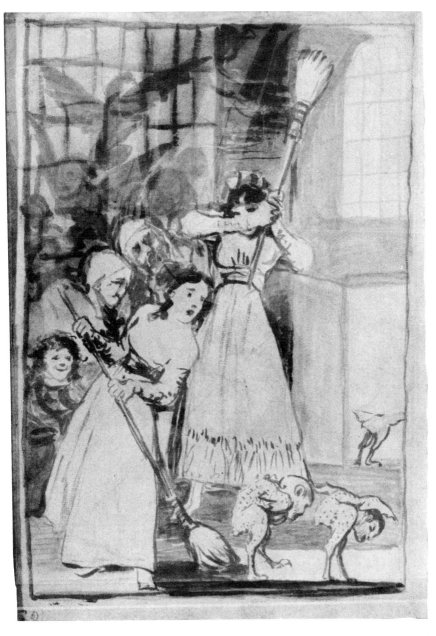

FIG. 125

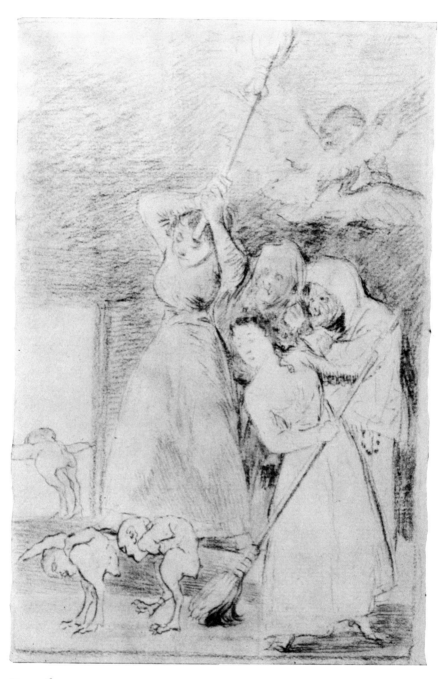

FIG. 126

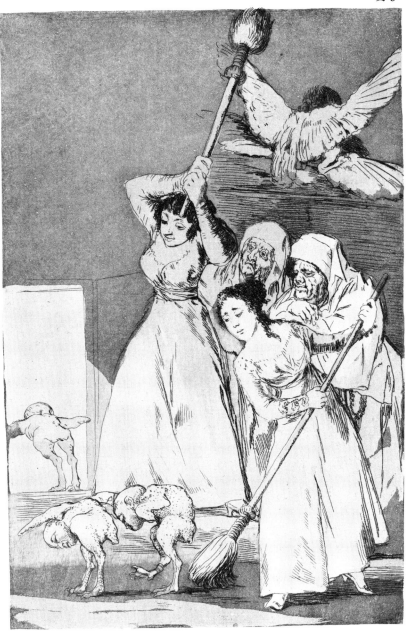

*Ya van desplumados.*

FIG. 127

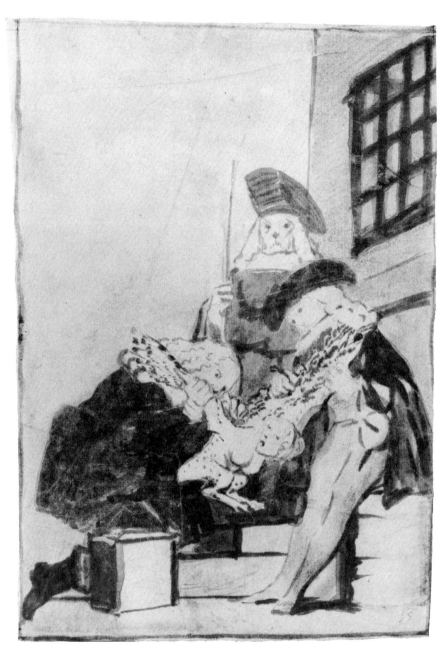

FIG. 128

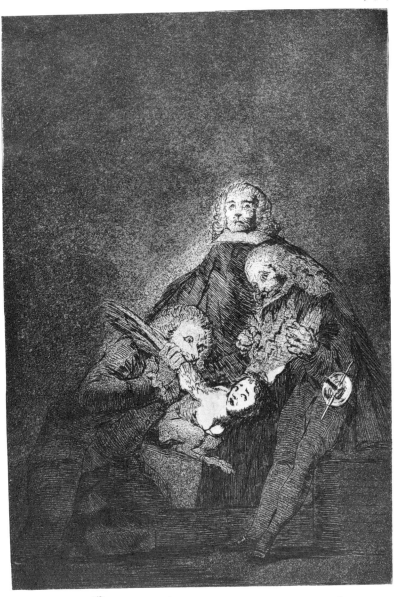

¡Qual la descanonan!

FIG. 129

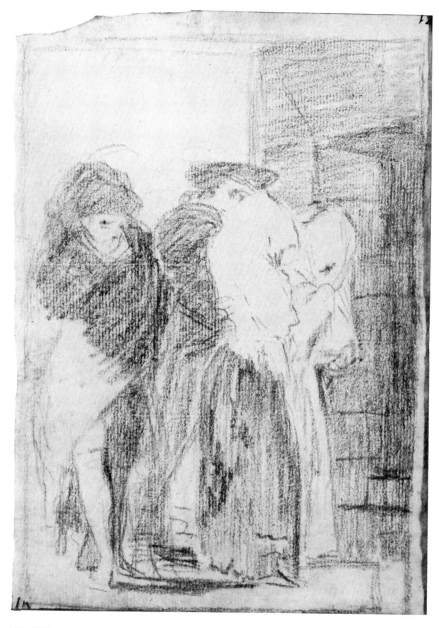

FIG. 130

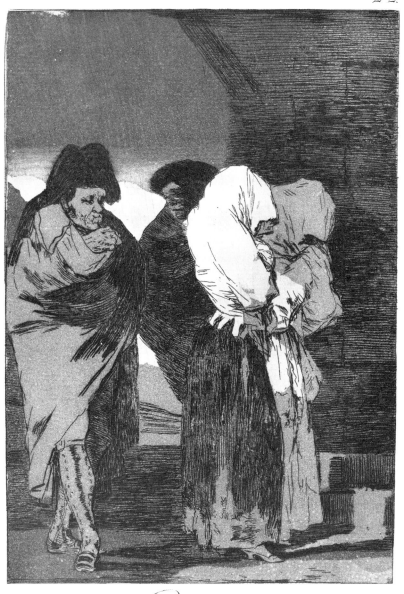

*Pobrecitas!*

FIG. 131

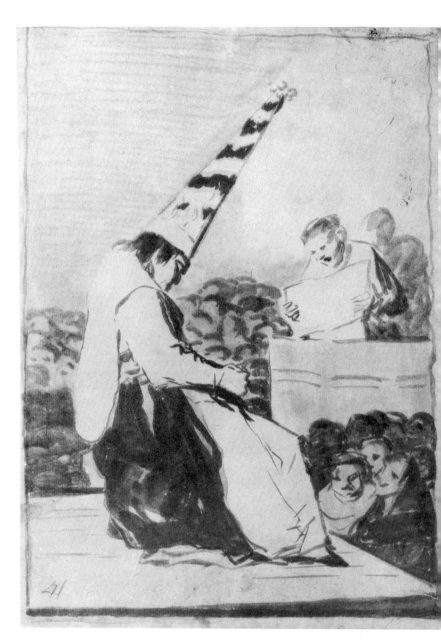

FIG. 132

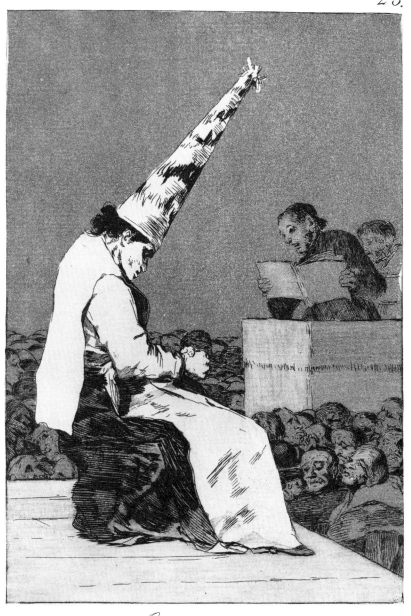

*Aquellos polbos.*

FIG. 133

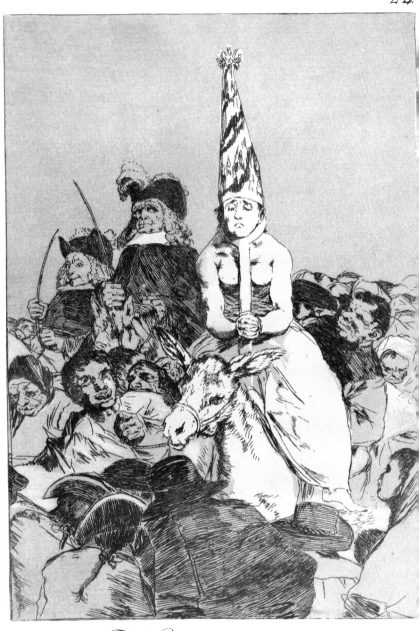

*Nohubo remedio.*

FIG. 134

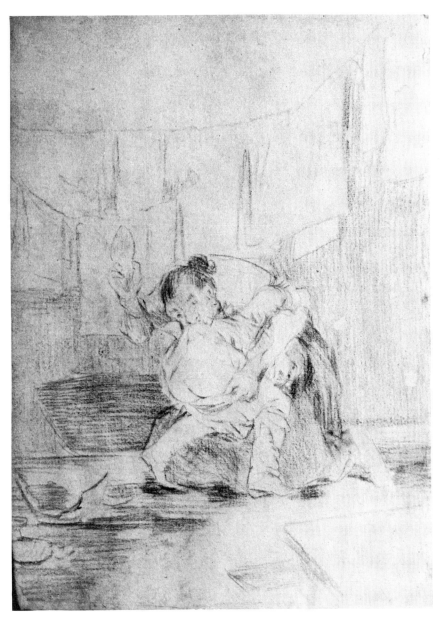

FIG. 135

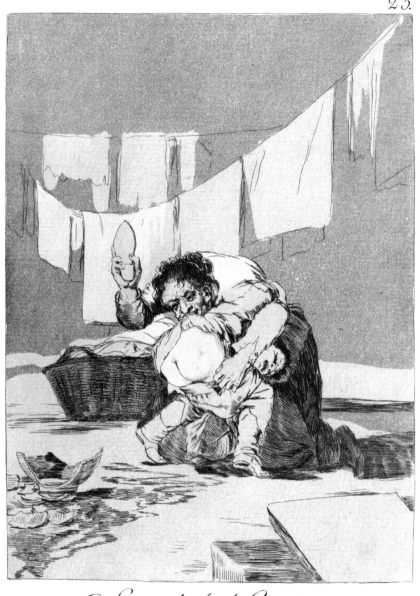

*Si quebró el Cantaro.*

FIG. 136

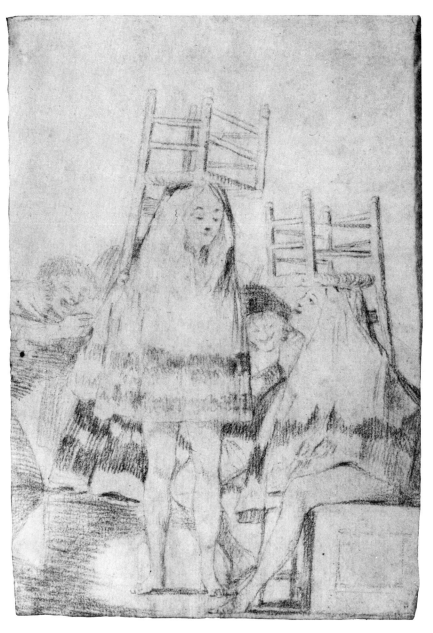

FIG. 137

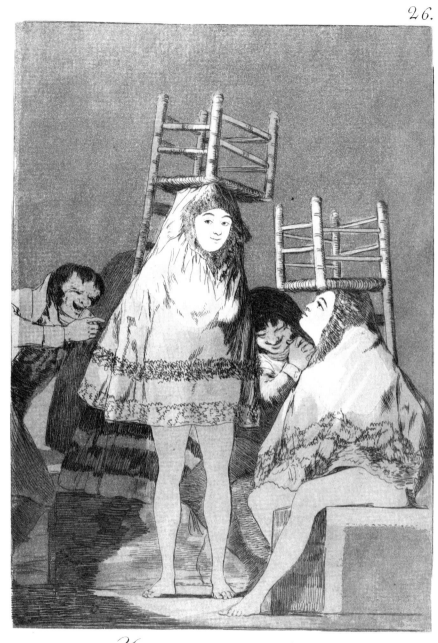

*Ya tienen asiento.*

FIG. 138

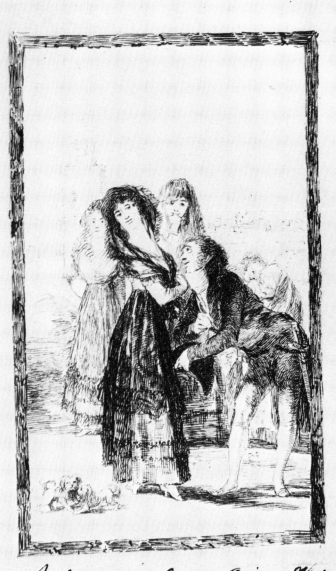

*Antiguo y moderno, Origen del orgullo*

FIG. 139

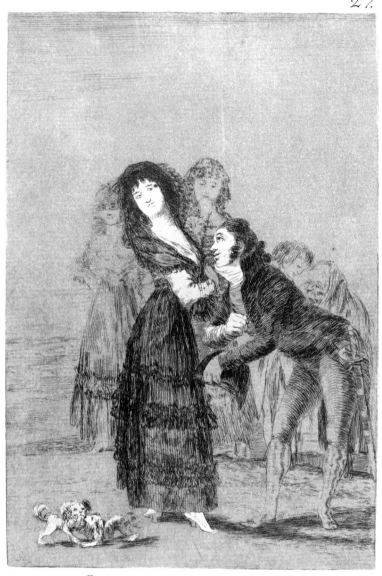

*Quién mas rendido?*

FIG. 140

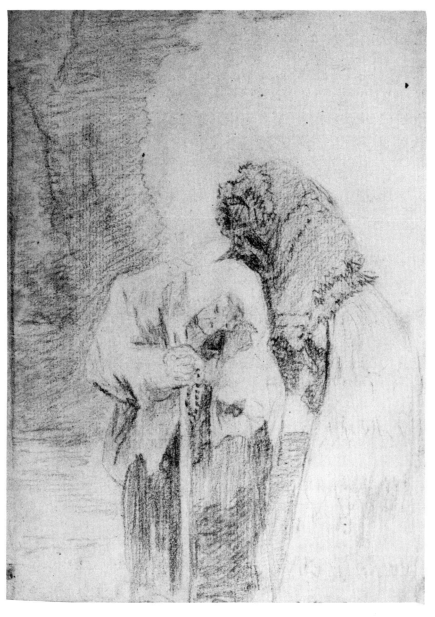

FIG. 141

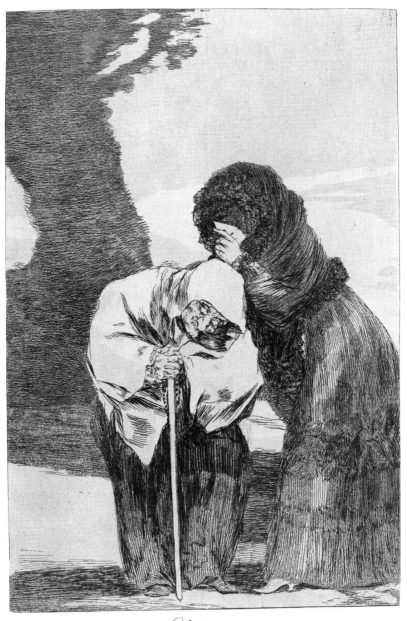

*Chiton.*

FIG. 142

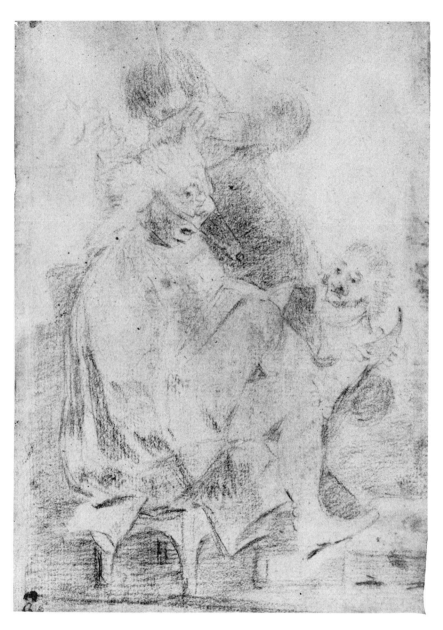

FIG. 143

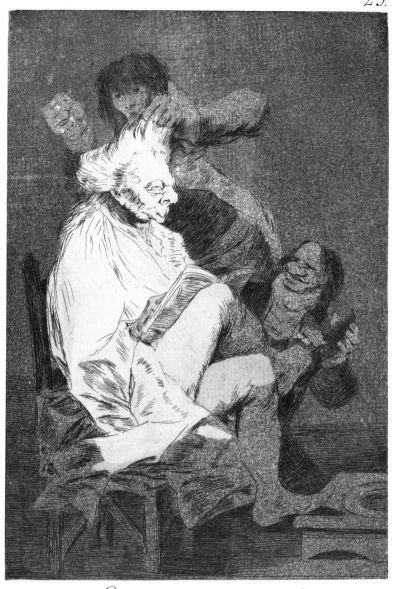

*Esto si que es leer.*

FIG. 144

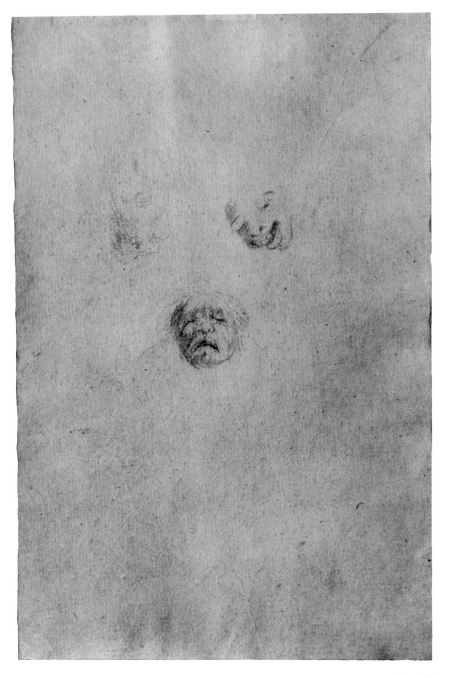

FIG. 145

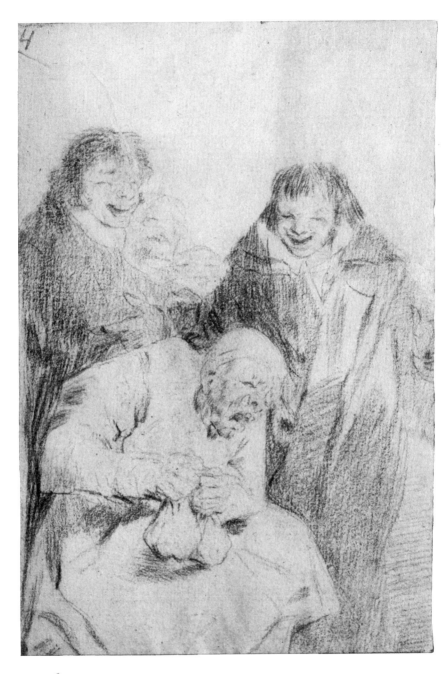

FIG. 146

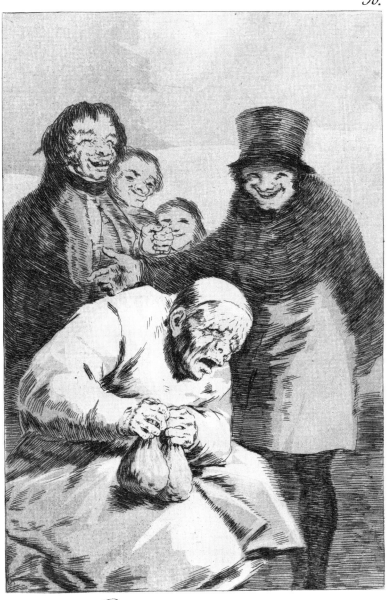

*Porque esconderlos?*

FIG. 147

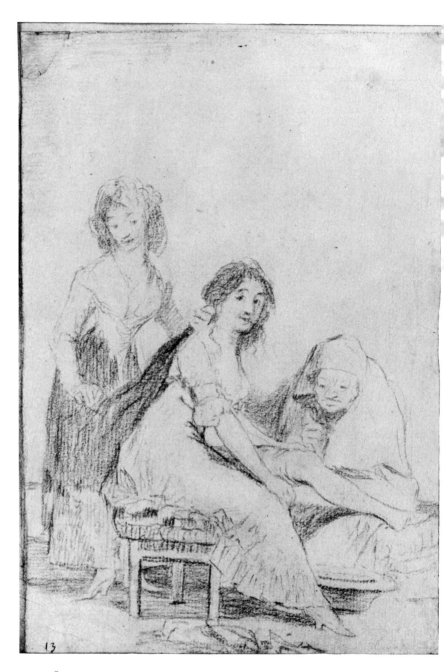

13

FIG. 148

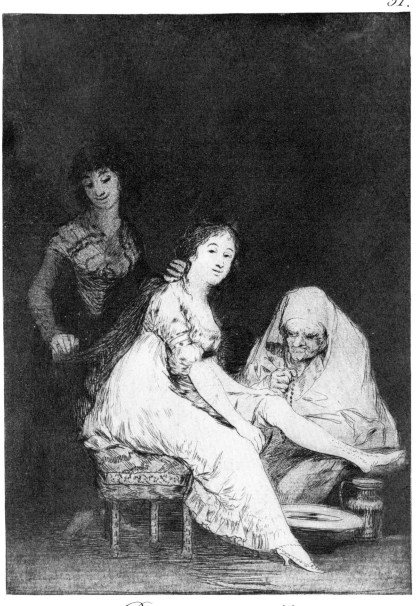

*Ruega por ella.*

FIG. 149

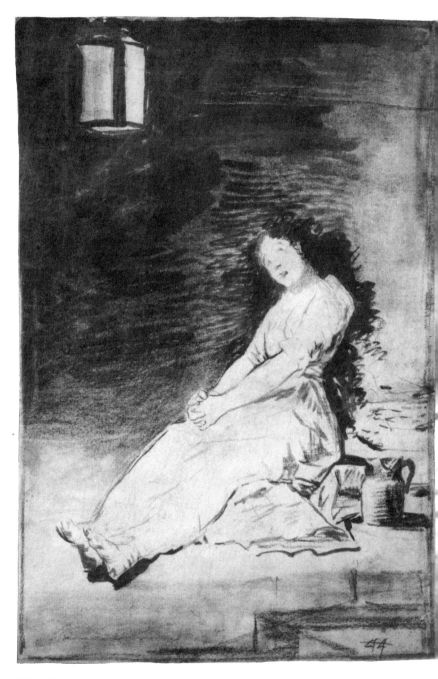

FIG. 150

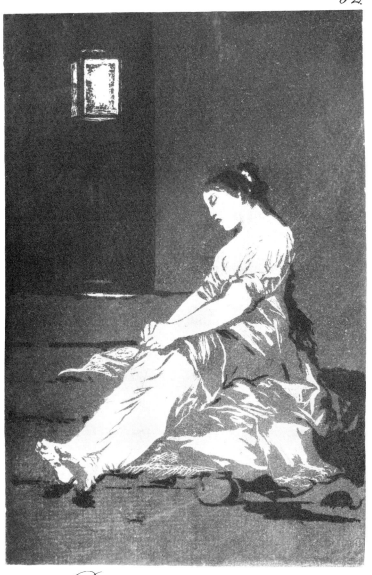

*Por que fue sensible.*

FIG. 151

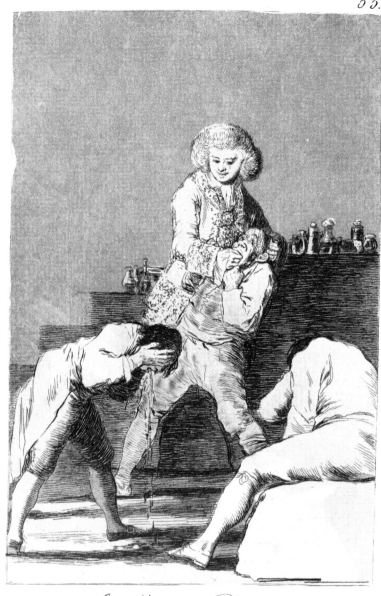

*Al Conde Palatino.*

FIG. 152

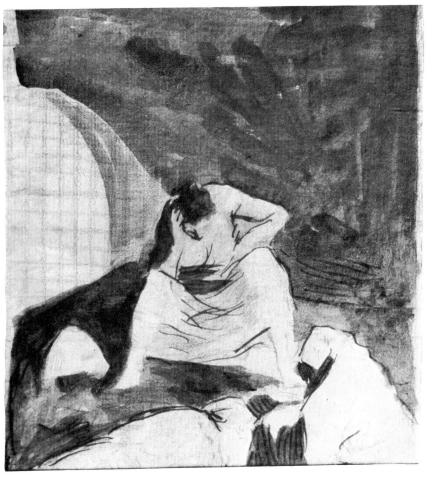

FIG. 153

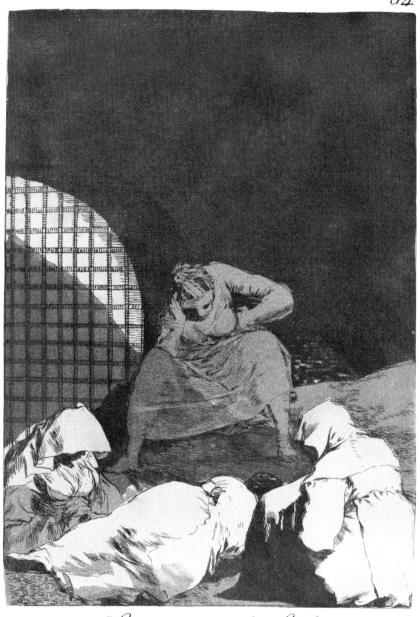

*Las rinde el Sueño.*

FIG. 154

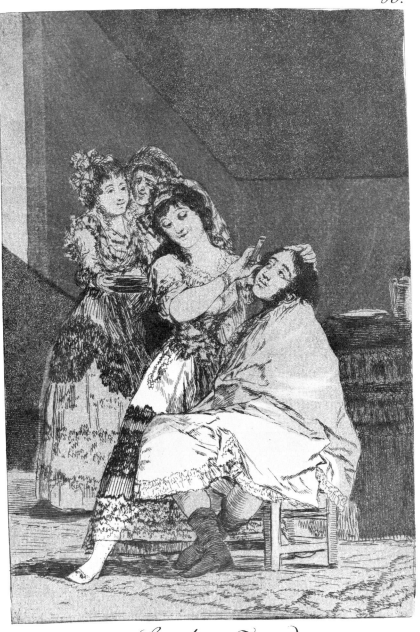

*Le descañona.*

FIG. 155

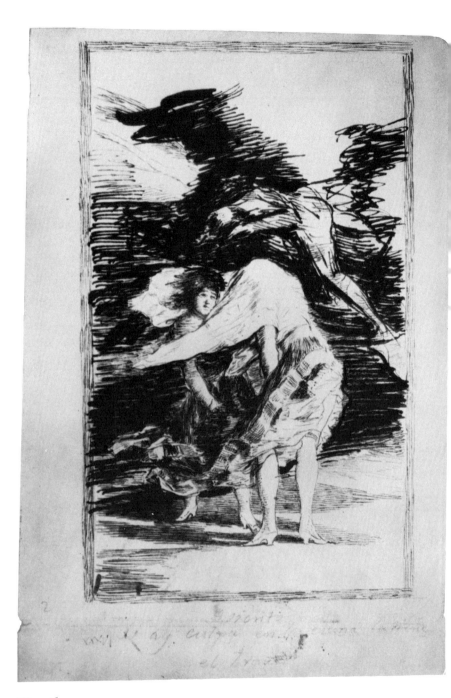

FIG. 156

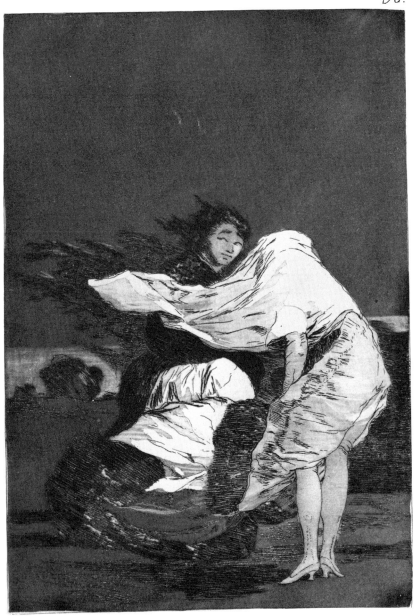

*Mala noche.*

FIG. 157

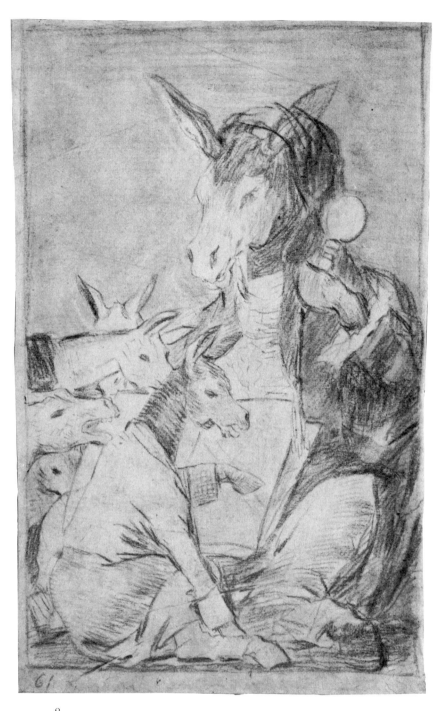

FIG. 158

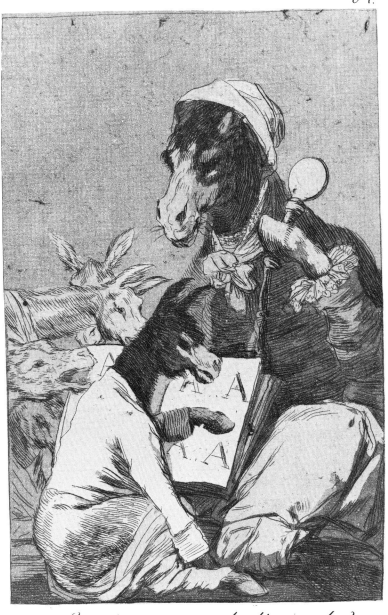

*Si sabrá mas el discipulo?*

FIG. 159

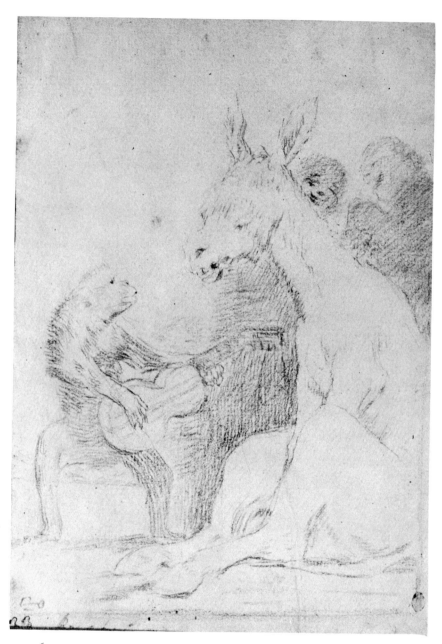

FIG. 160

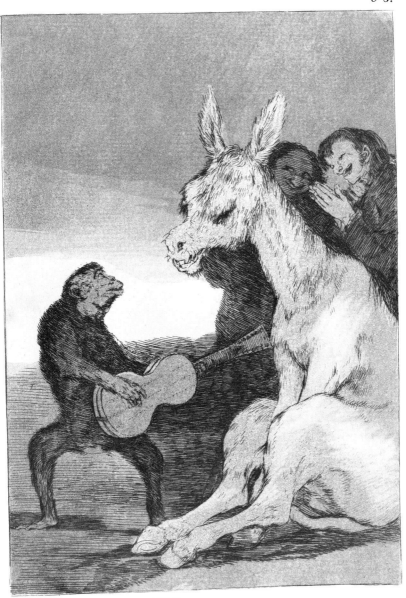

*Brabisimo!*

FIG. 161

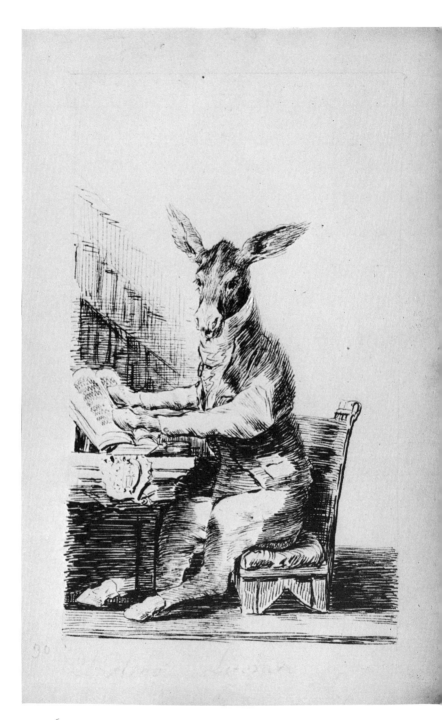

FIG. 162

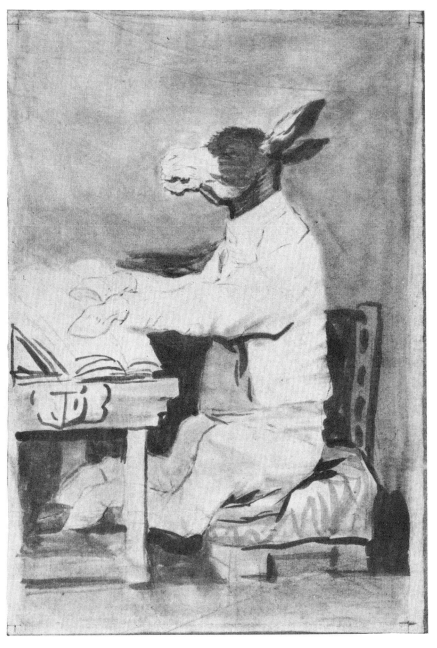

FIG. 163

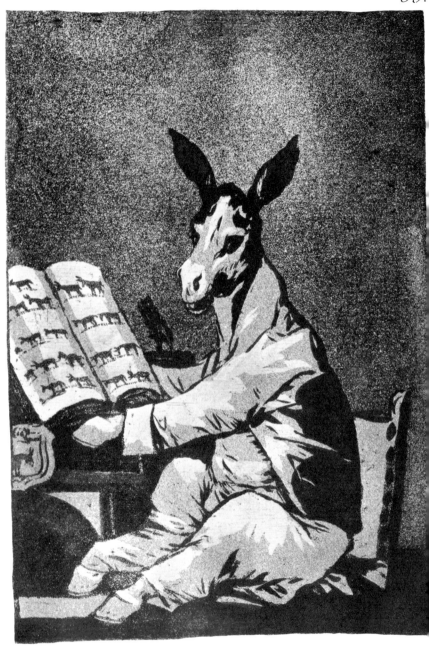

*Asta su Abuelo.*

FIG. 164

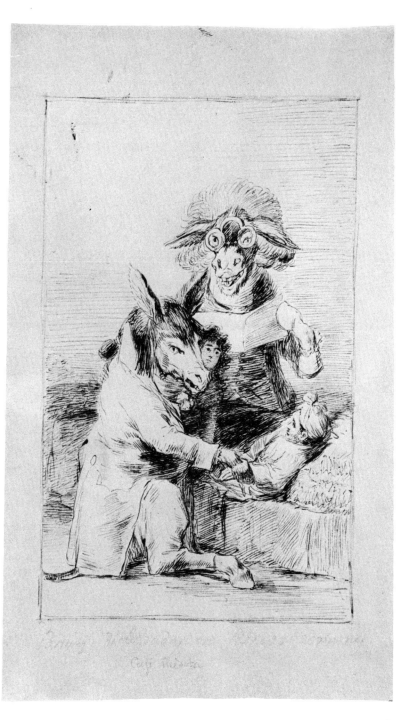

FIG. 165

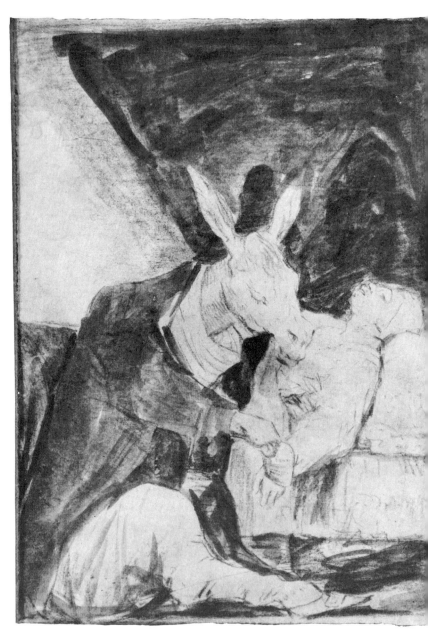

FIG. 166

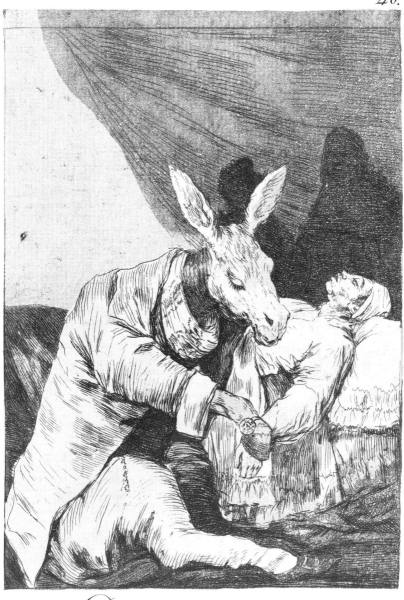

*De que mal morira?*

FIG. 167

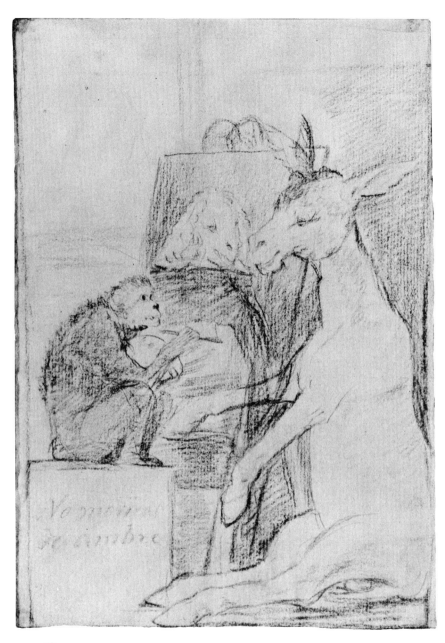

FIG. 168

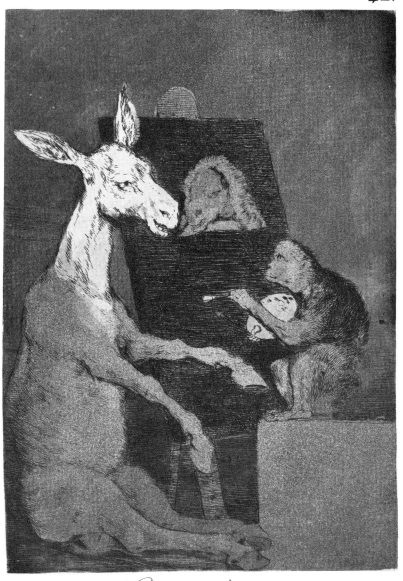

*Ni mas ni menos.*

FIG. 169

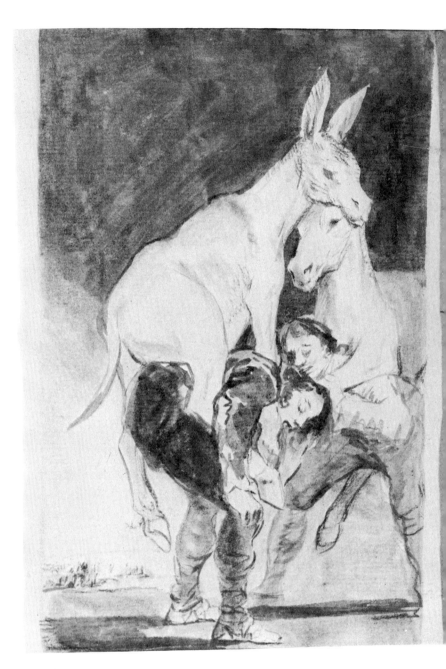

FIG. 170

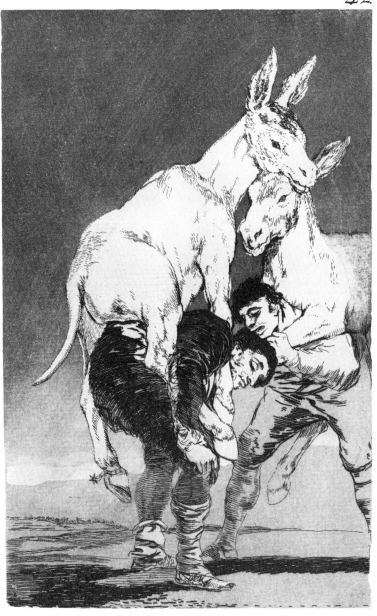

*Tu que no puedes.*

FIG. 171

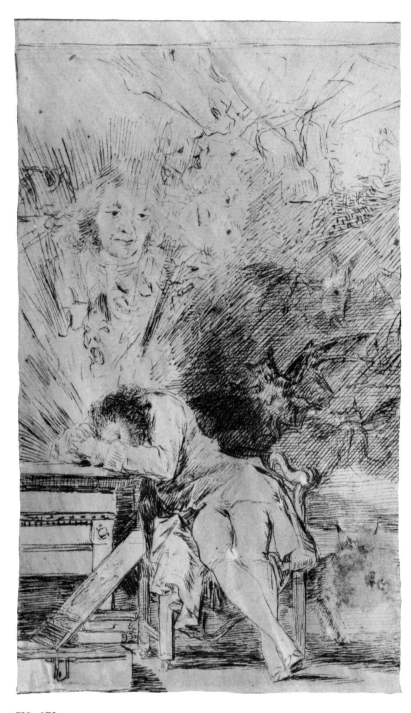

FIG. 172

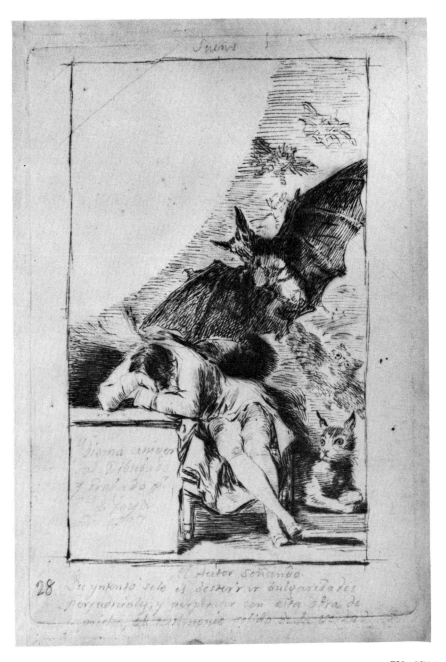

FIG. 173

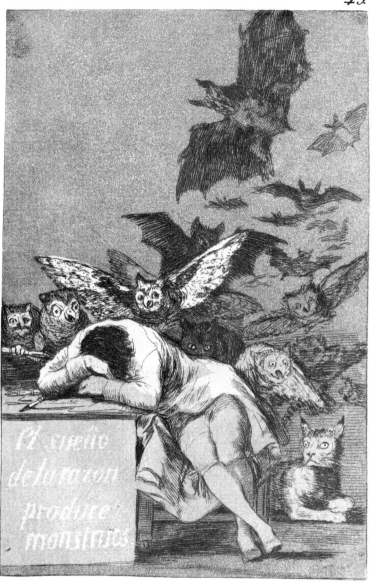

El sueño
de la razon
produce
monstruos

FIG. 174

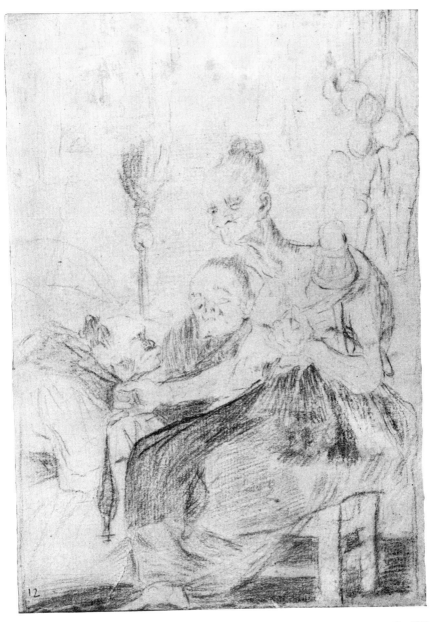

FIG. 175

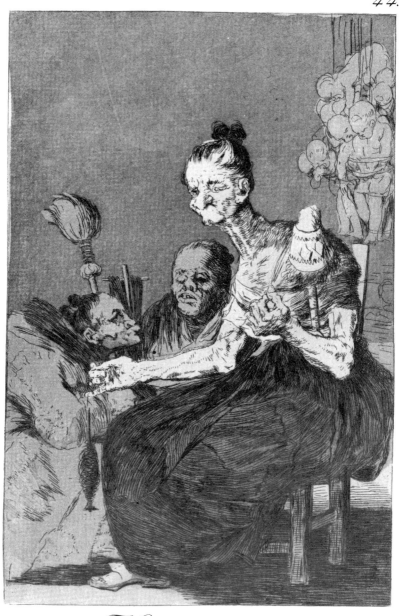

*Hilan delgado.*

FIG. 176

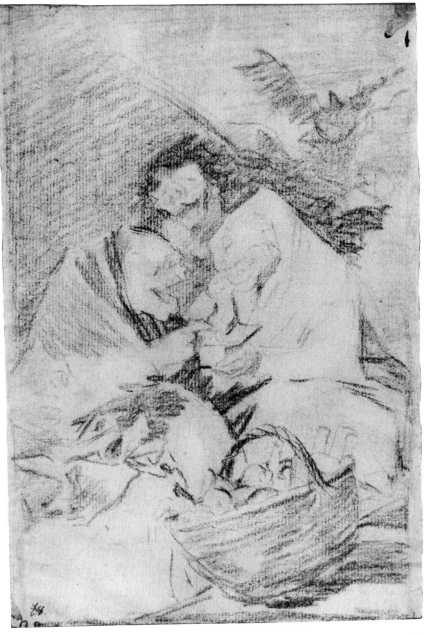

FIG. 177

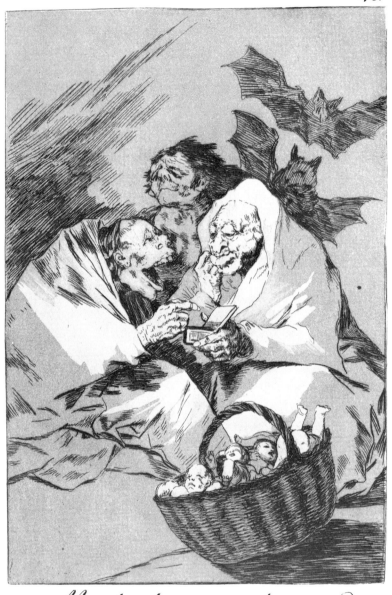

*Mucho hay que chupar.*

FIG. 178

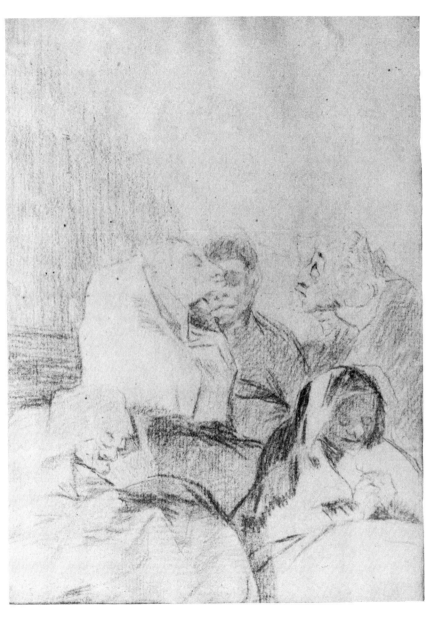

FIG. 179

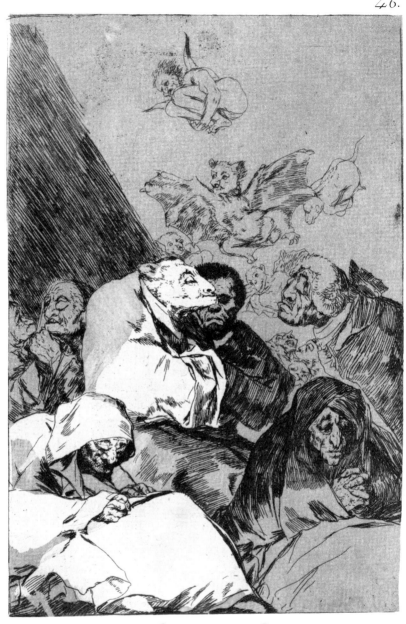

*Correccion.*

FIG. 180

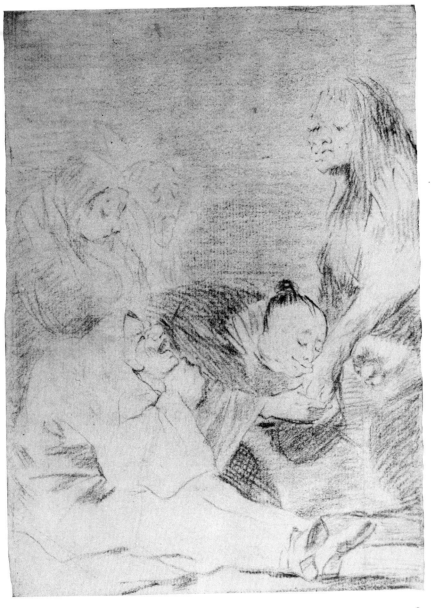

FIG. 181

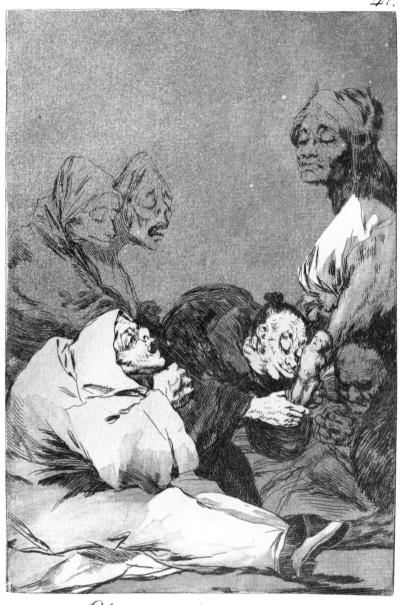

*Obsequio á el maestro.*

FIG. 182

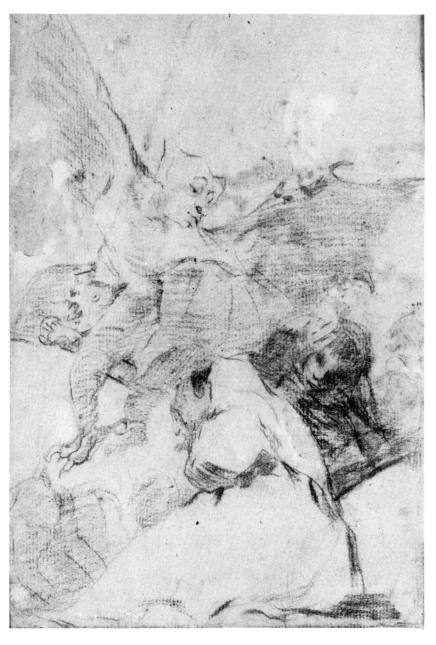

FIG. 183

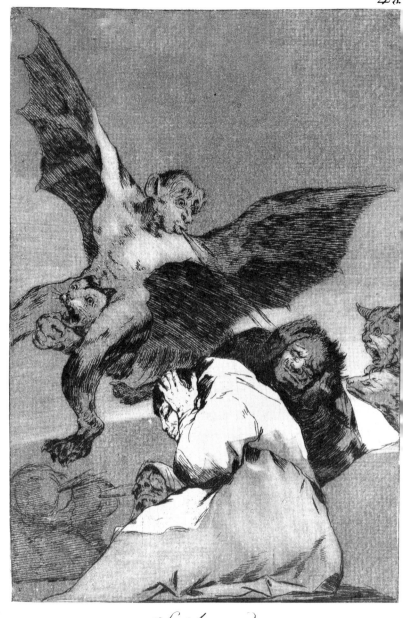

*Soplones?*

FIG. 184

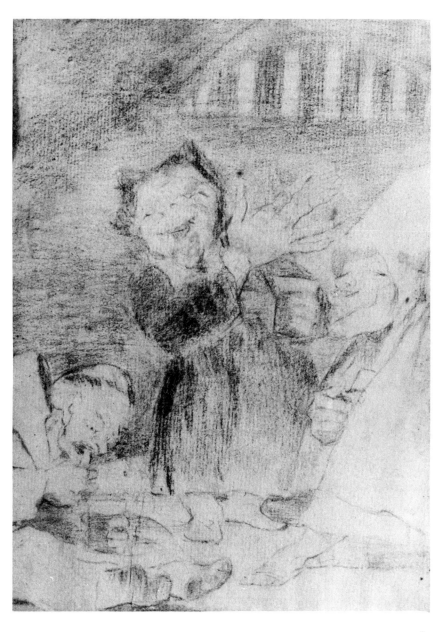

FIG. 185

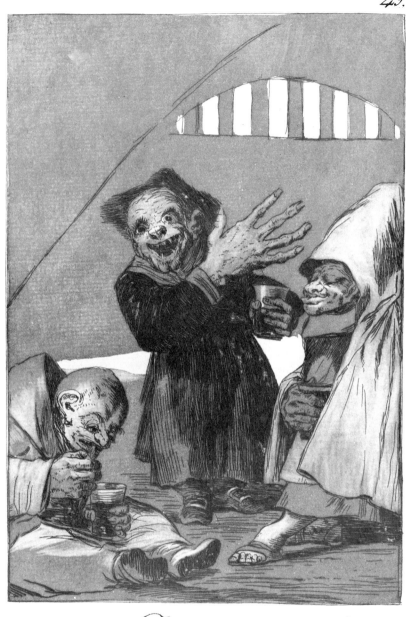

*Duendecitos.*

FIG. 186

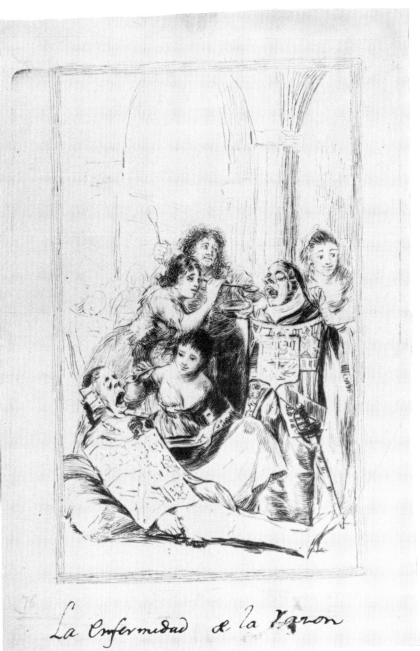

La Enfermedad de la Razon

FIG. 187

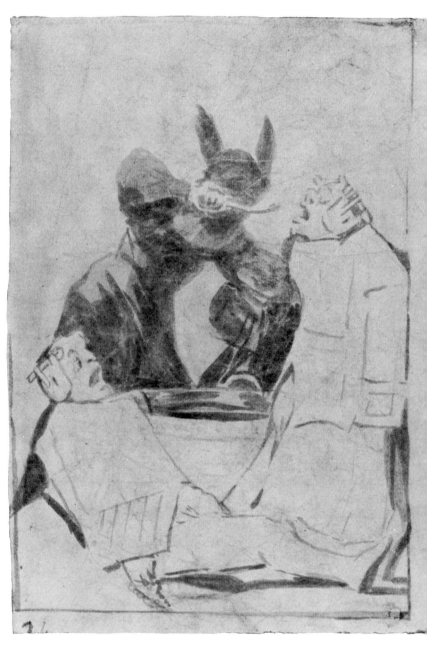

FIG. 188

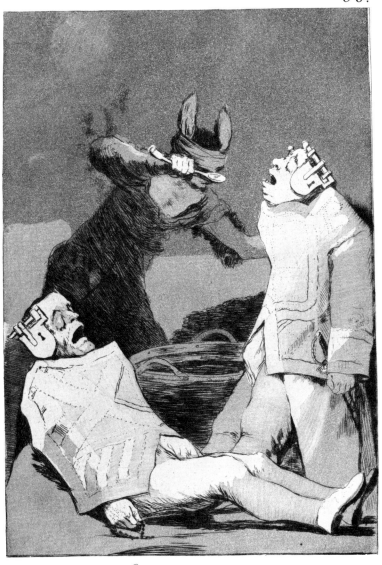

Las Chinchillas.

FIG. 189

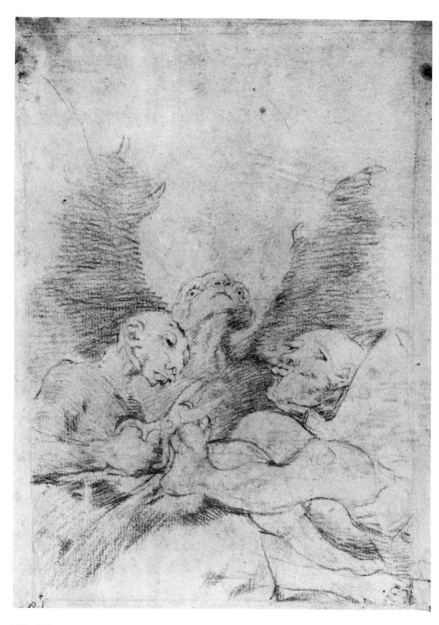

FIG. 190

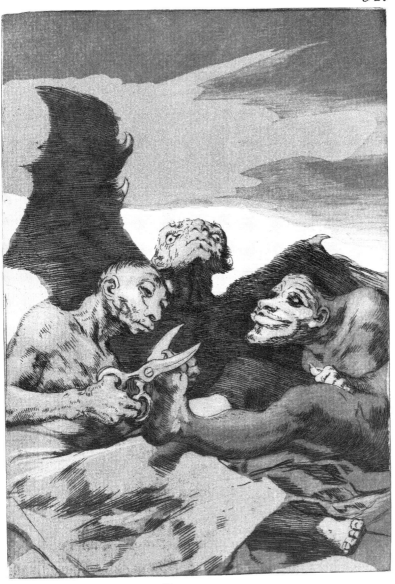

*Se repilen.*

FIG. 191

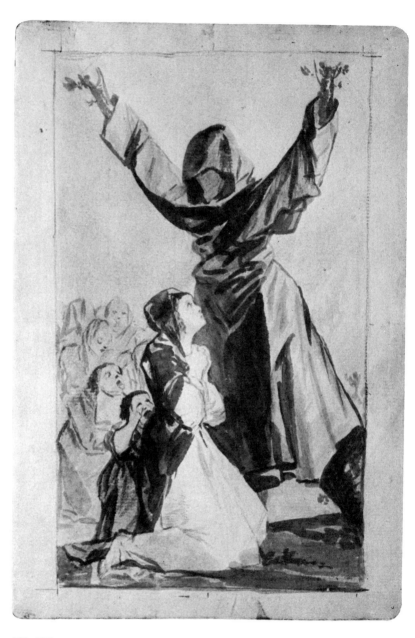

FIG. 192

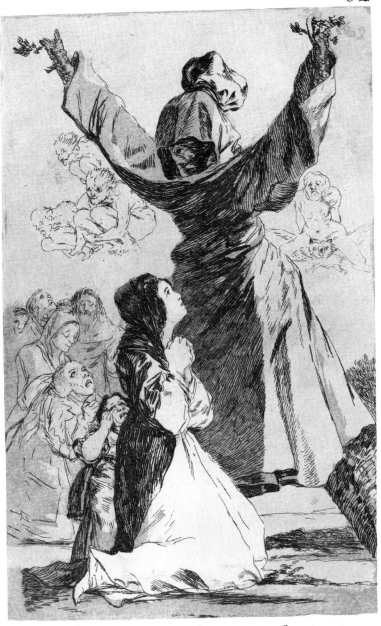

*Lo que puede un Sastre!*

FIG. 193

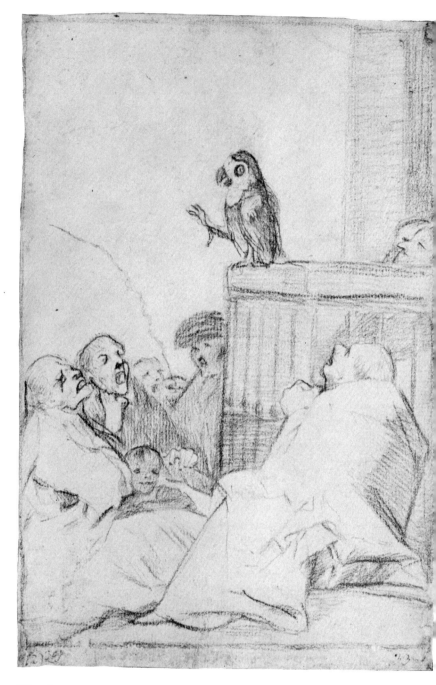

FIG. 194

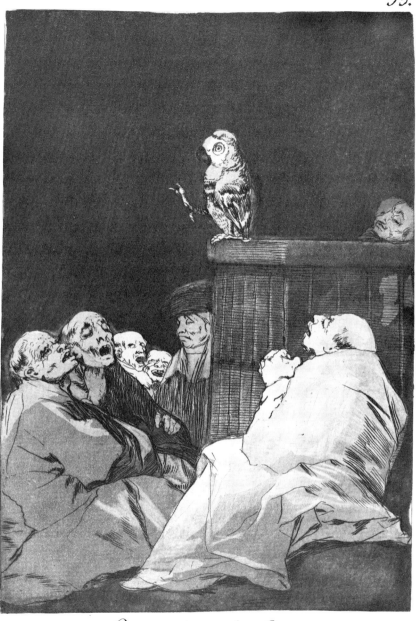

*Que pico de Oro!*

FIG. 195

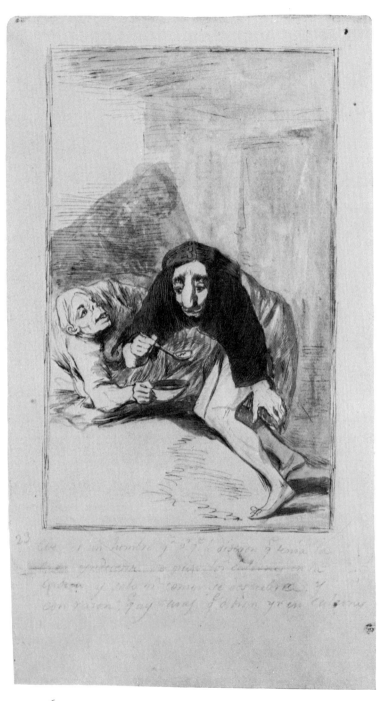

FIG. 196

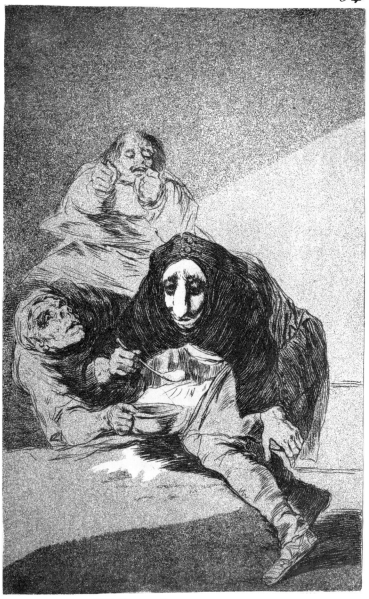

*El Vergonzoso.*

FIG. 197

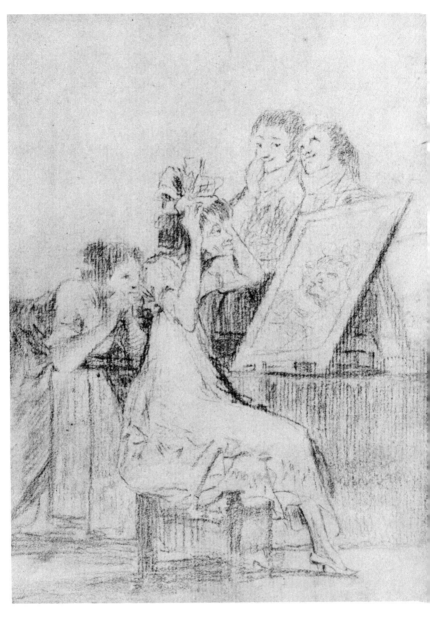

FIG. 198

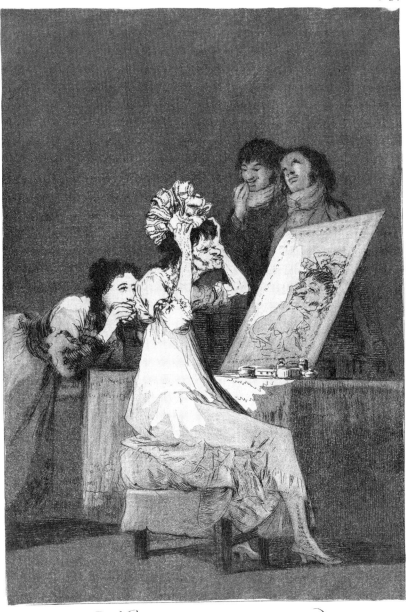

*Hasta la muerte.*

FIG. 199

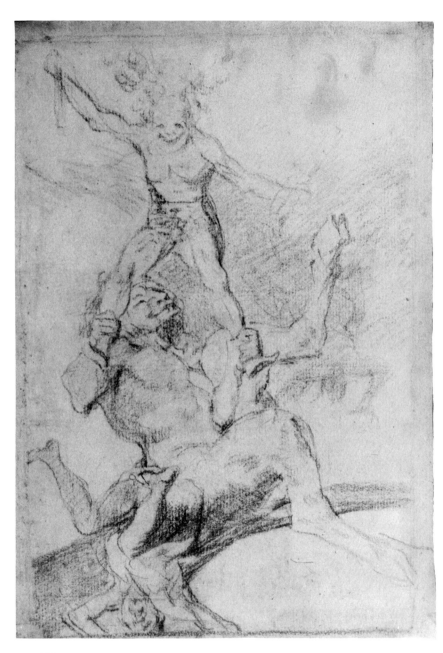

FIG. 200

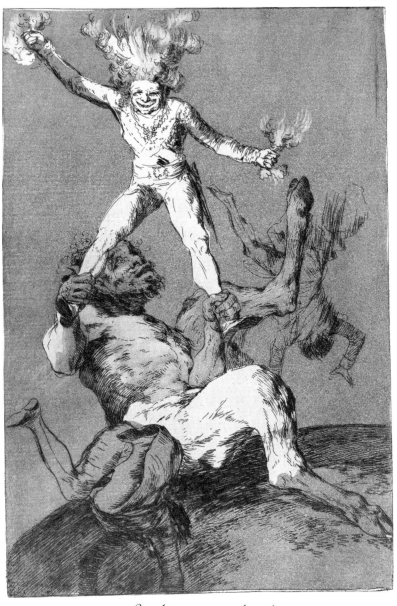

*Subir y bajar.*

FIG. 201

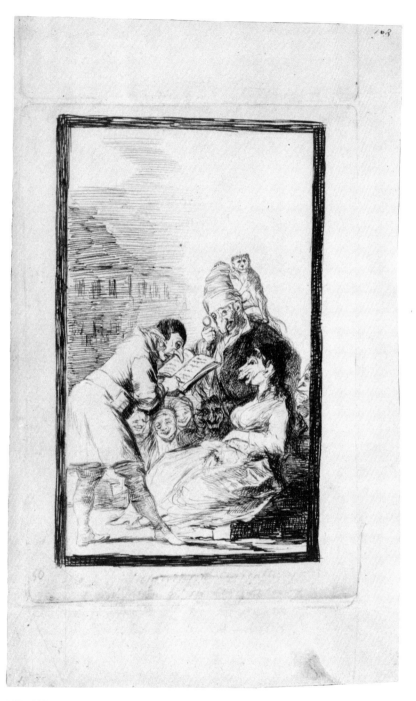

FIG. 202

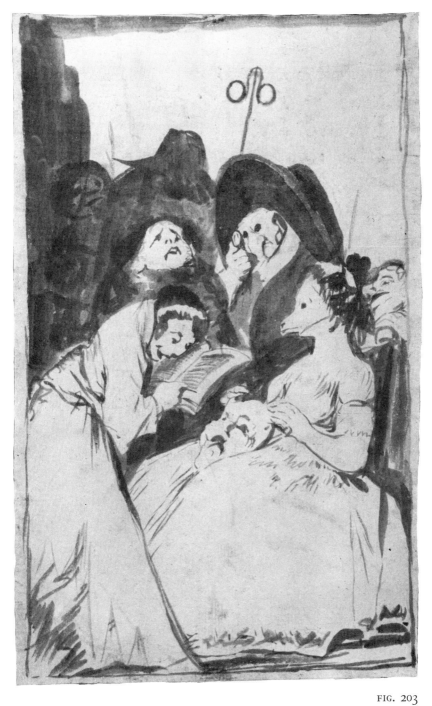

FIG. 203

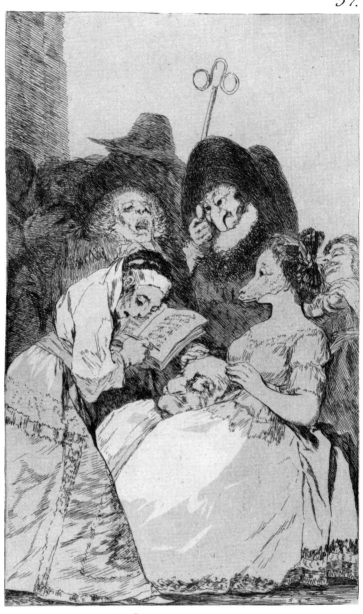

La filiacion.

FIG. 204

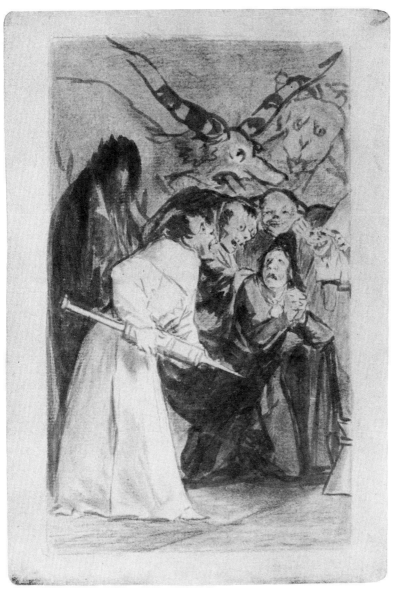

FIG. 205

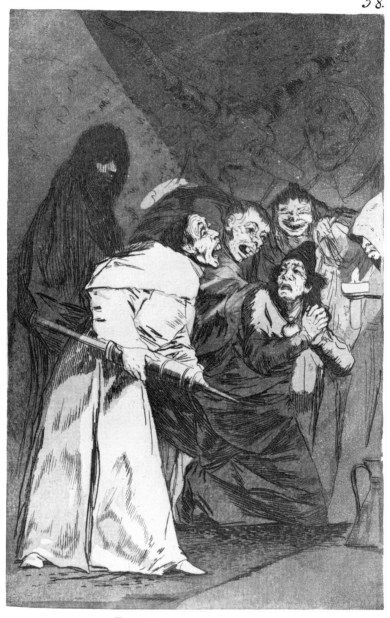

*Tragala perro.*

FIG. 206

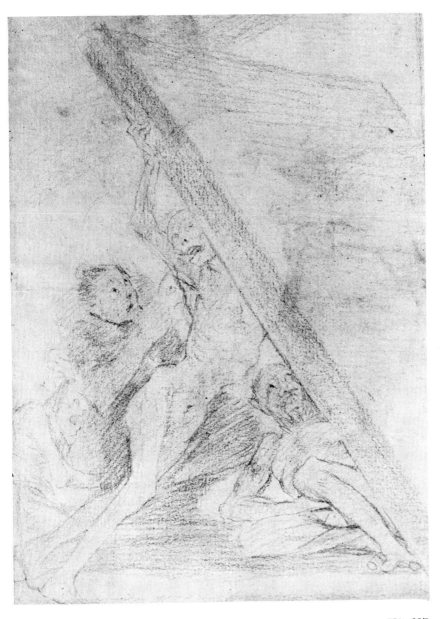

FIG. 207

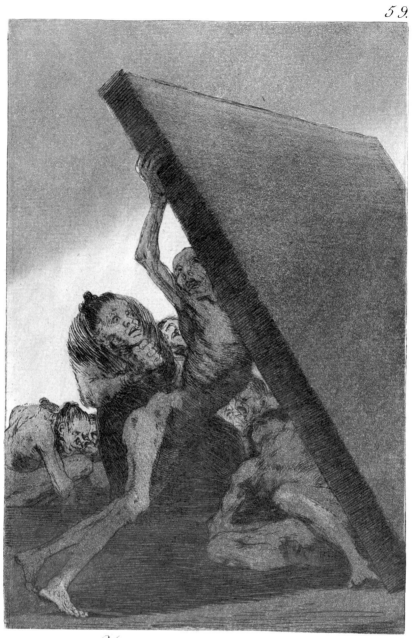

*Y aun no se van!*

FIG. 208

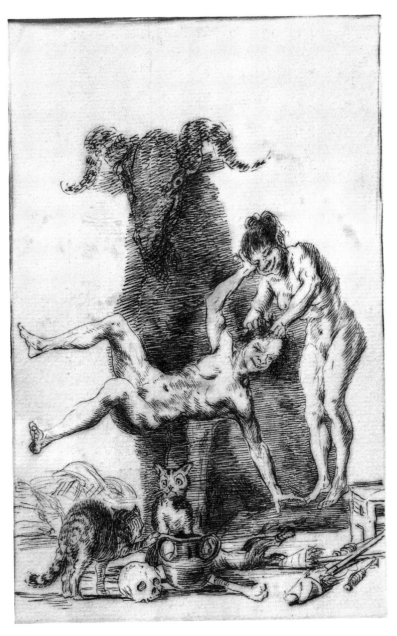

FIG. 209

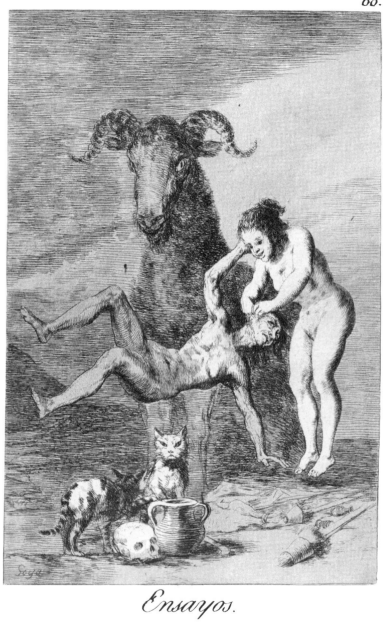

*Ensayos.*

FIG. 210

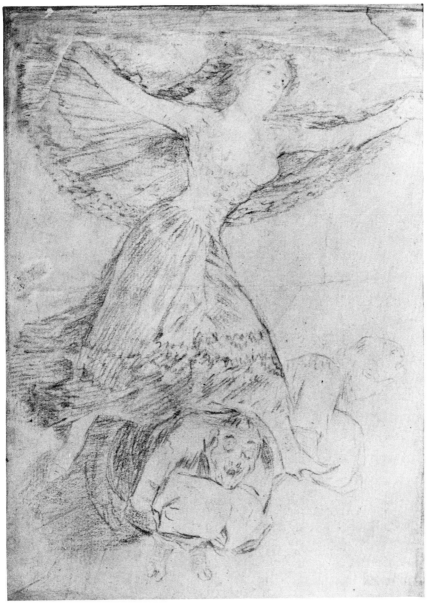

FIG. 211

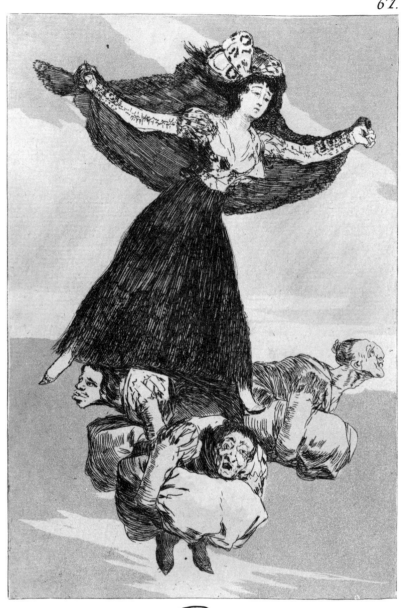

*Volaverunt.*

FIG. 212

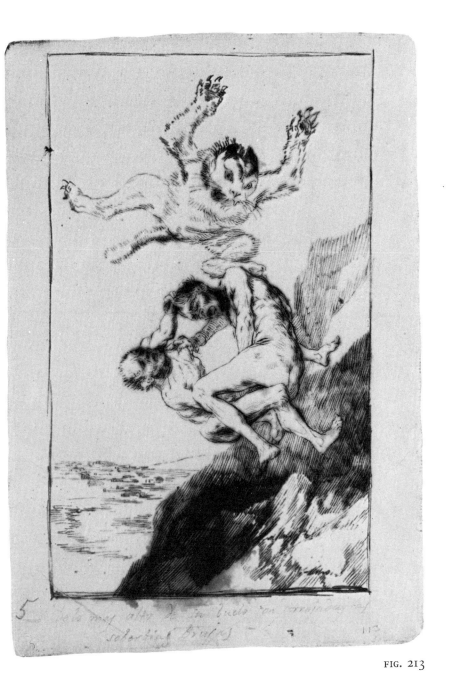

5

FIG. 213

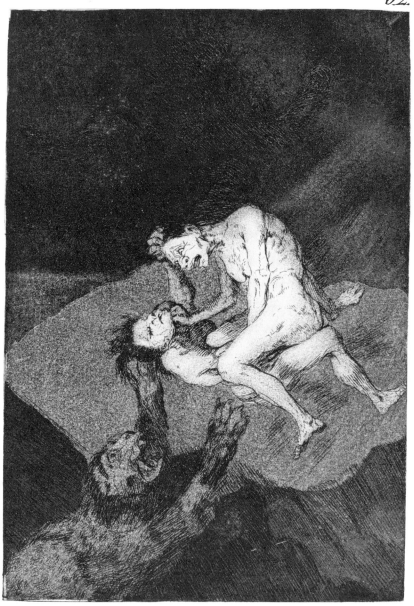

*Quien lo creyera!*

FIG. 214

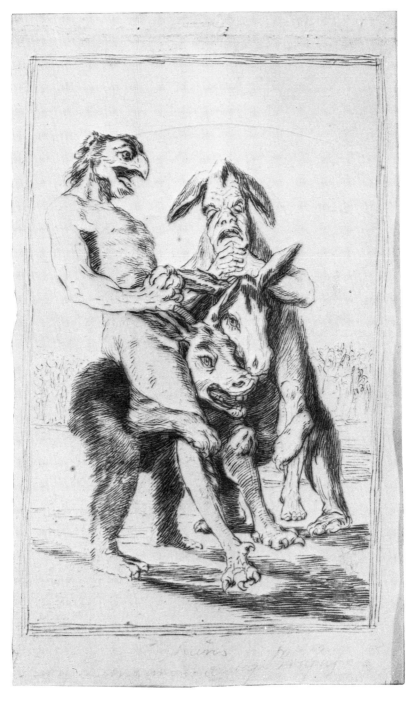

FIG. 215

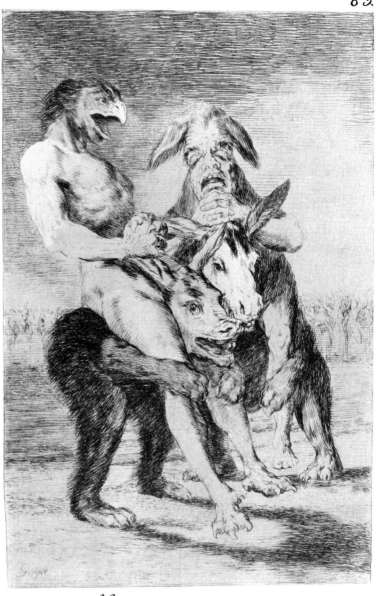

*Miren que grabes!*

FIG. 216

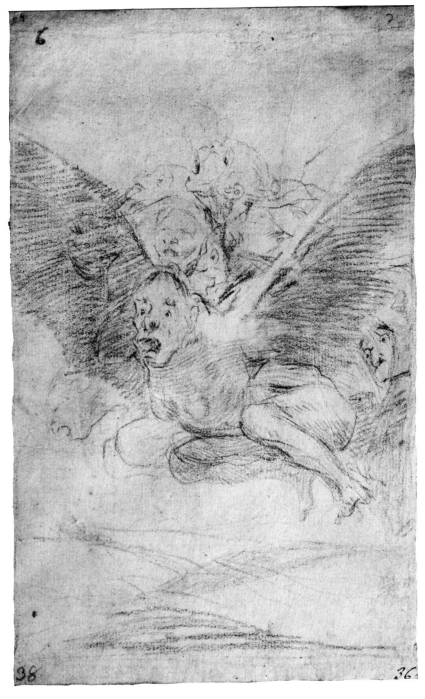

FIG. 217

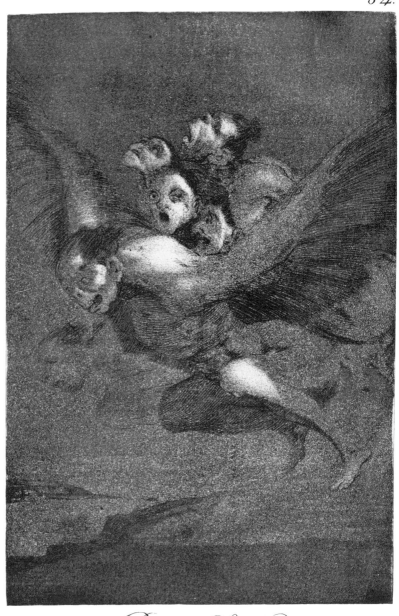

*Buen Viage*

FIG. 218

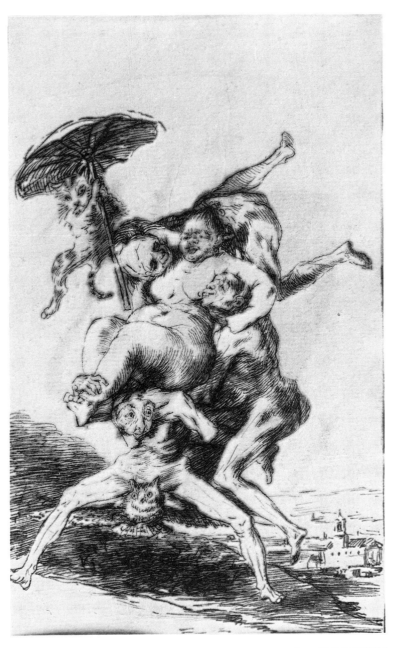

Sueño.

Bruja poderosas que por ydropica, sacan a paseo las mejores bolaoras.

FIG. 219

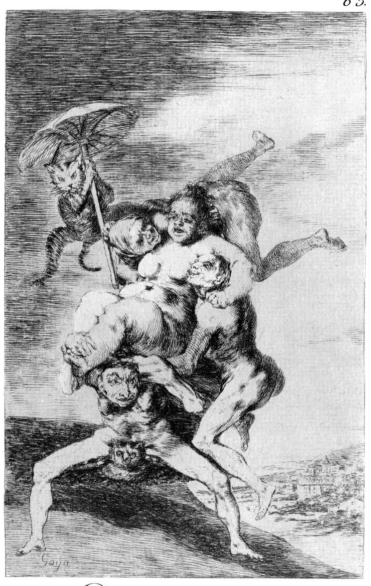

Donde vá mamá?

FIG. 220

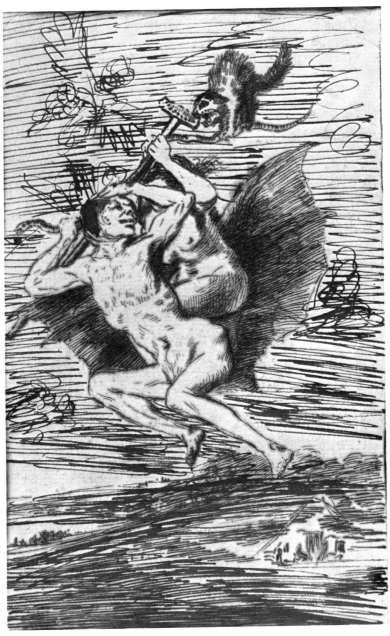

Sueño.
Bruja maestra Dando lecciones a su discipulo del primer buelo.

FIG. 221

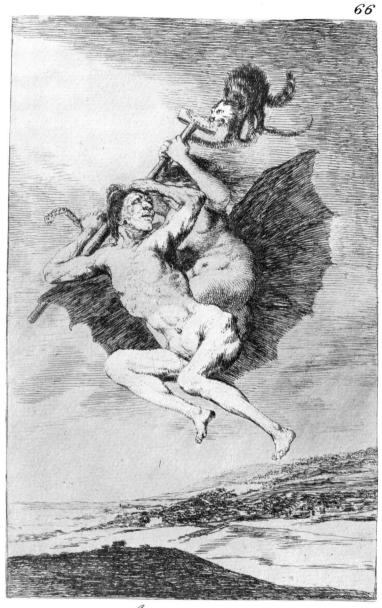

*Allá vá eso.*

FIG. 222

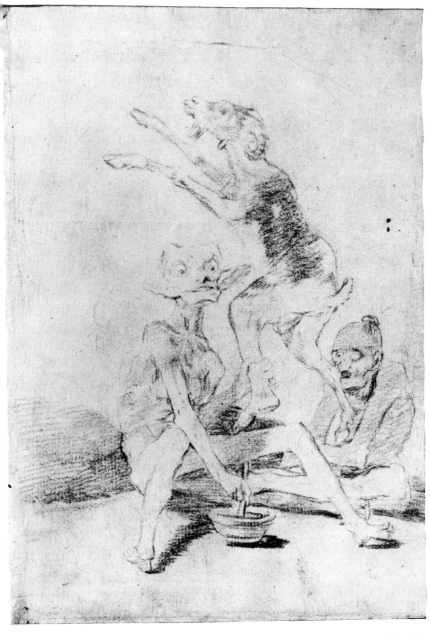

FIG. 223

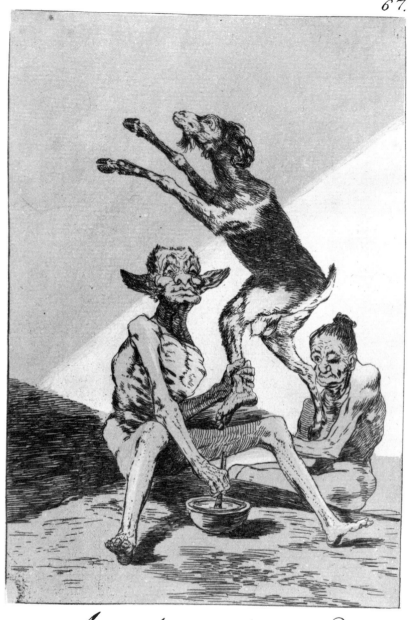

*Aguarda que te unten).*

FIG. 224

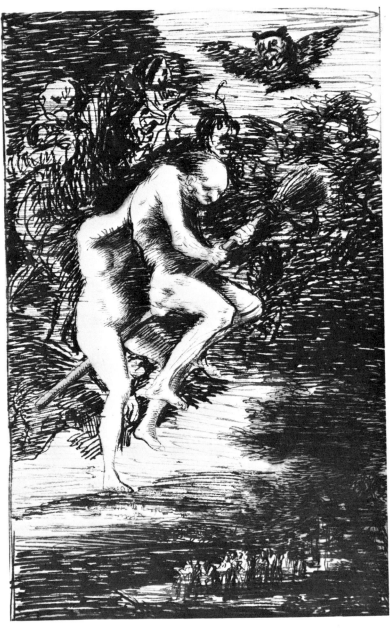

FIG. 225

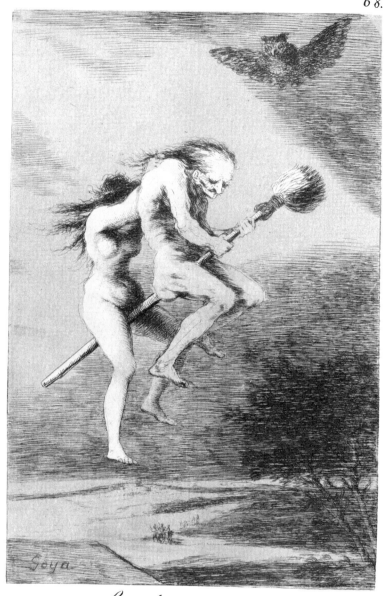

*Linda maestra!*

FIG. 226

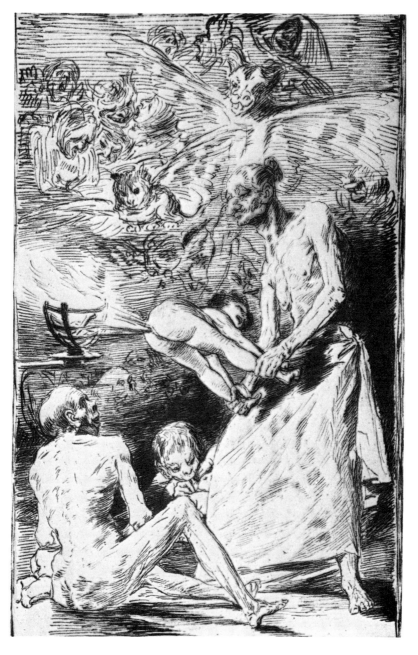

FIG. 227

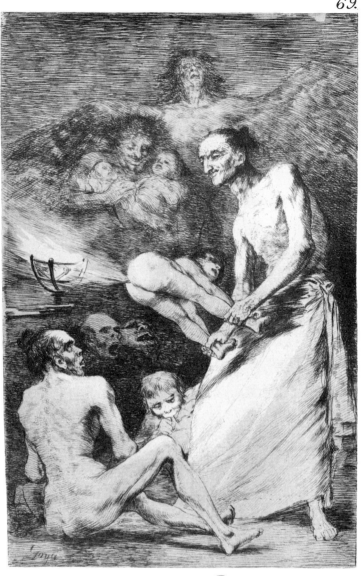

*Sopla.*

FIG. 228

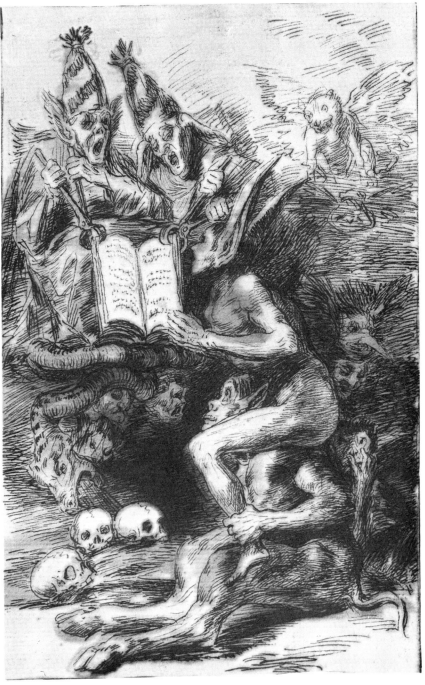

FIG. 229

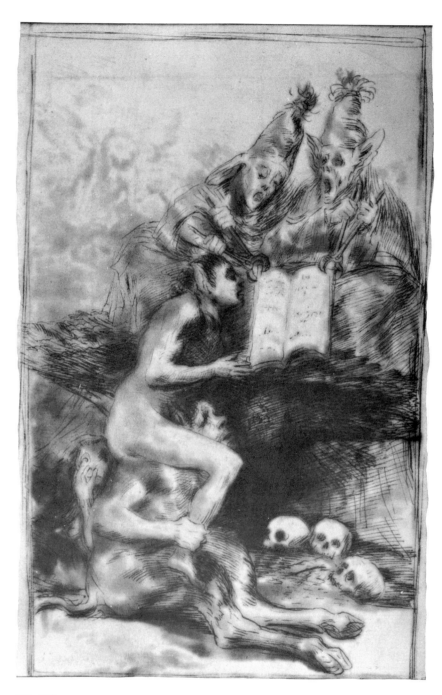

FIG. 230

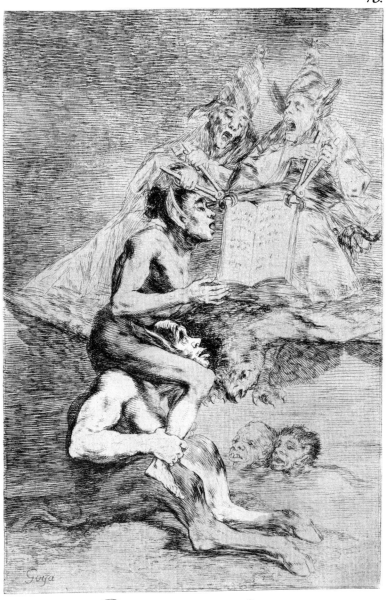

*Devota profesion.*

FIG. 231

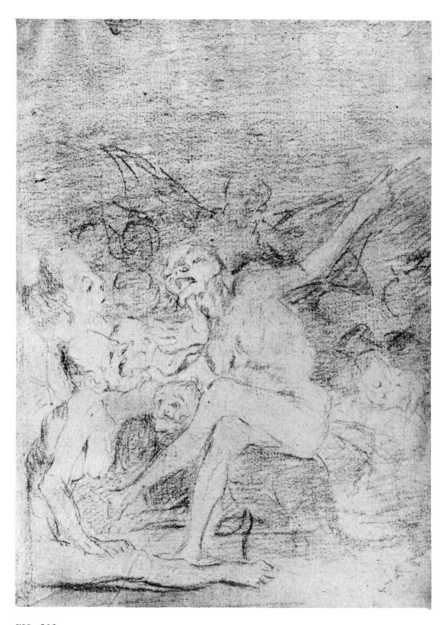

FIG. 232

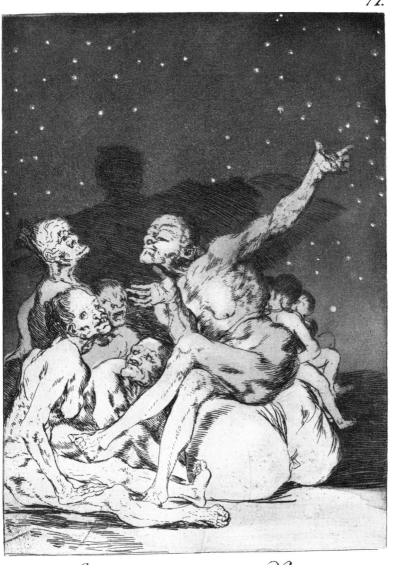

*Si amanece ; nos Vamos.*

FIG. 233

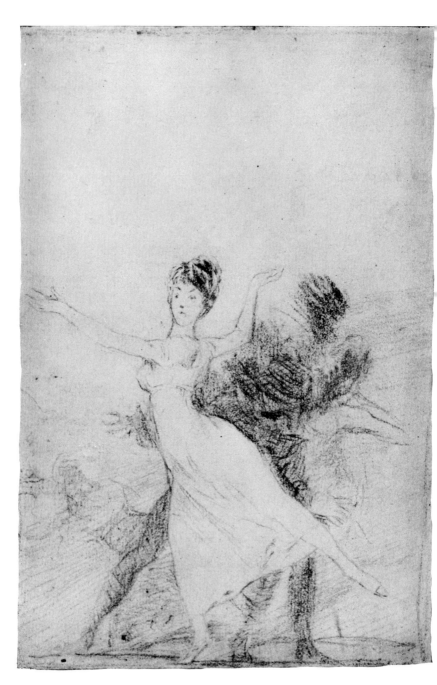

FIG. 234

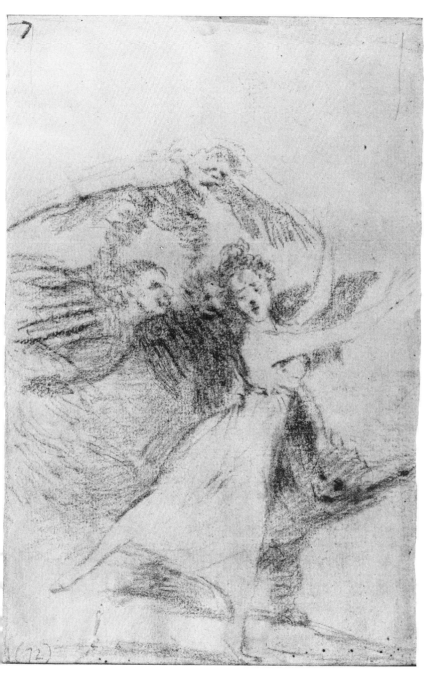

FIG. 235

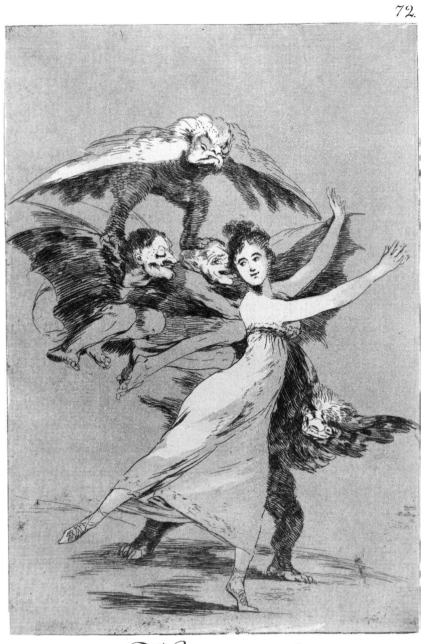

No te escaparás

FIG. 236

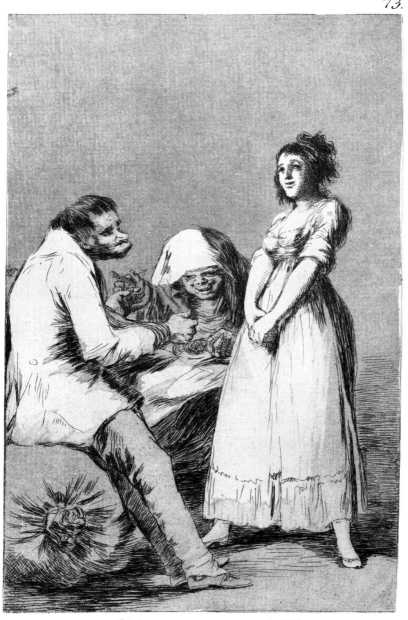

*Mejor es holgàr.*

FIG. 237

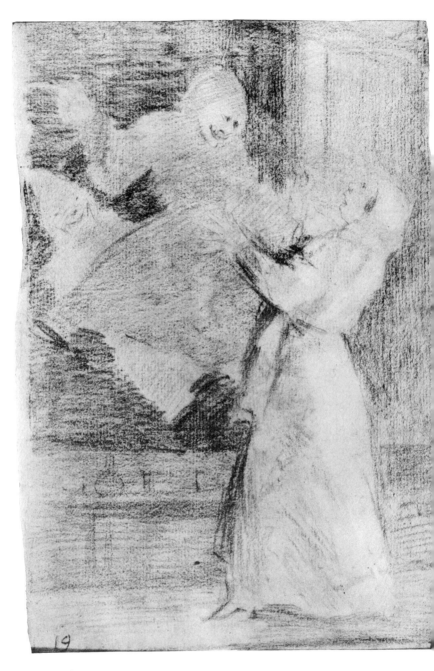

FIG. 238

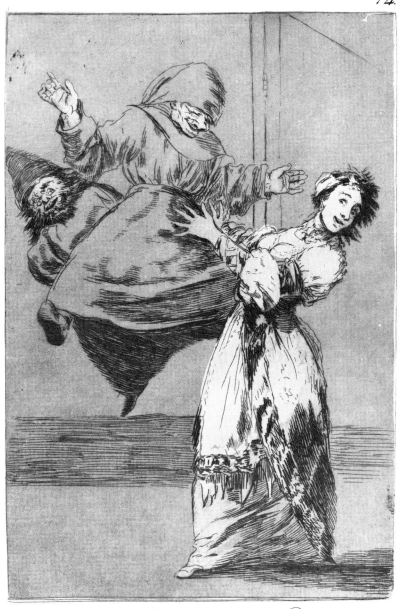

*No grites, tonta.*

FIG. 239

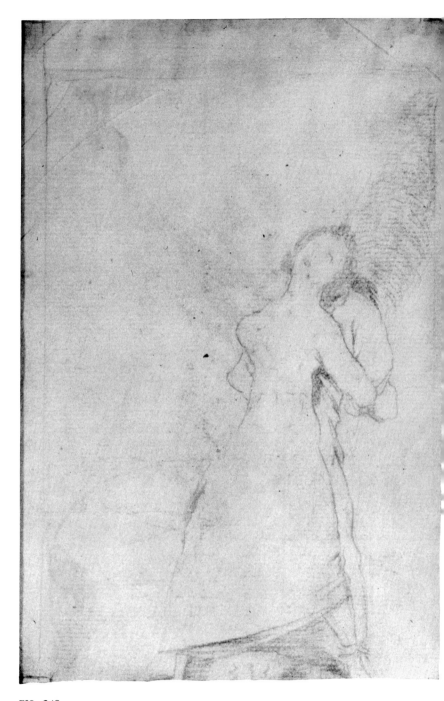

FIG. 240

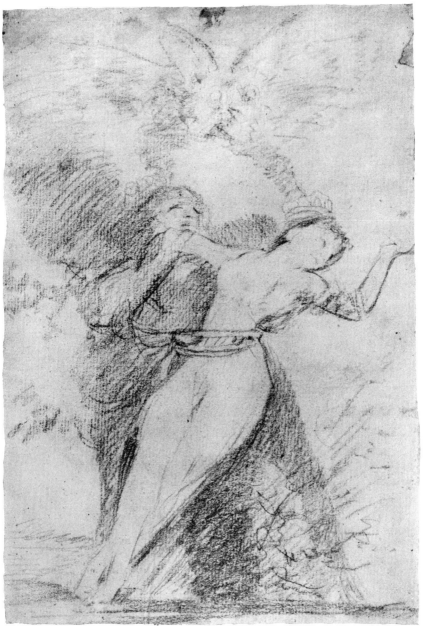

FIG. 241

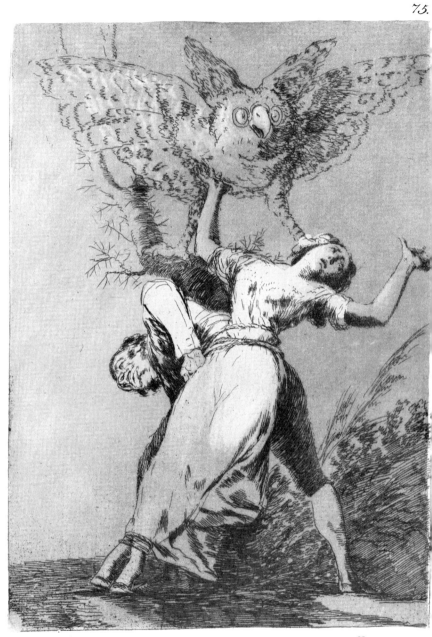

*¿No hay quien nos desate?*

FIG. 242

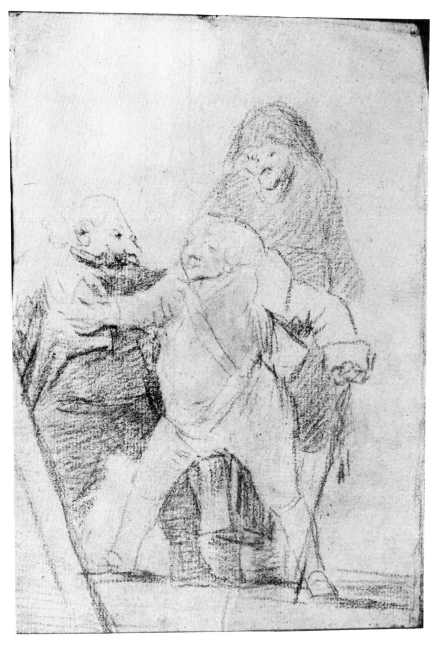

FIG. 243

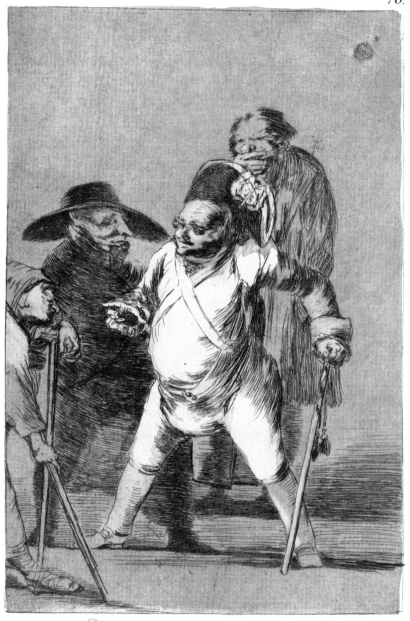

¿Està Vm.d pues, Como digo.. eh¡Cuidado¡si nó..

FIG. 244

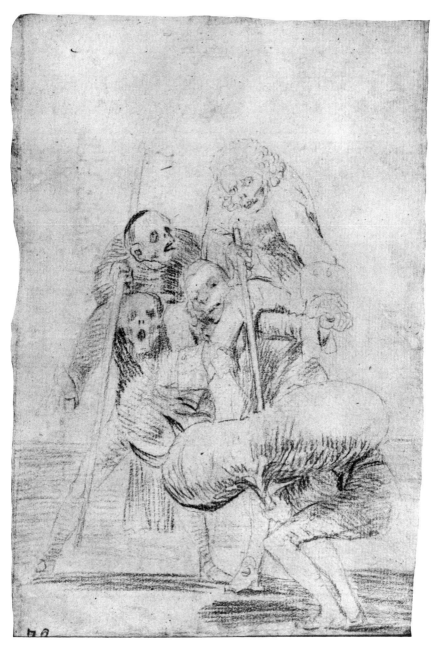

FIG. 245

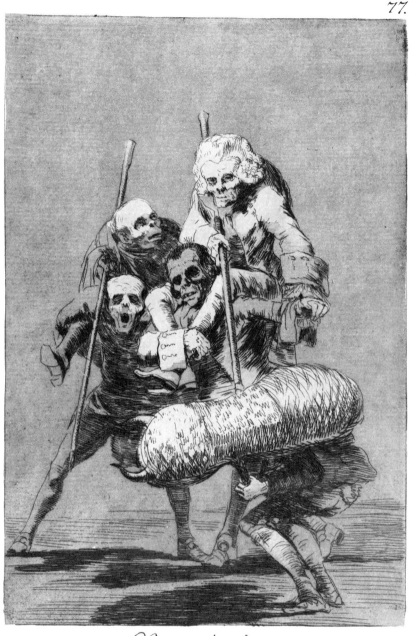

*Unos à otros.*

FIG. 246

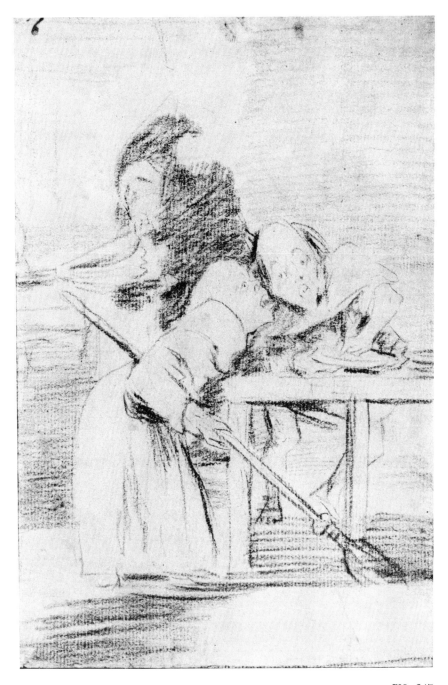

FIG. 247

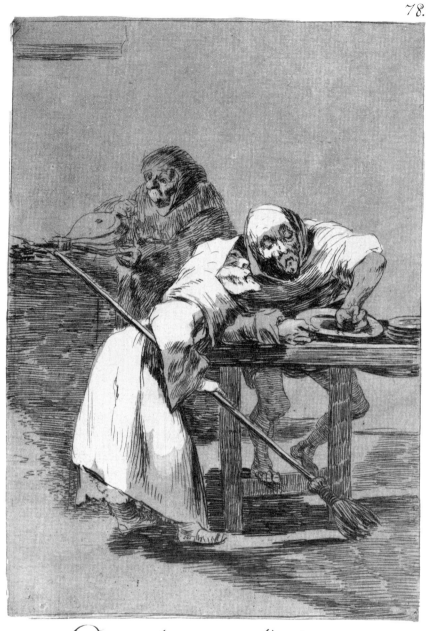

*Despacha, que dispiertan.*

FIG. 248

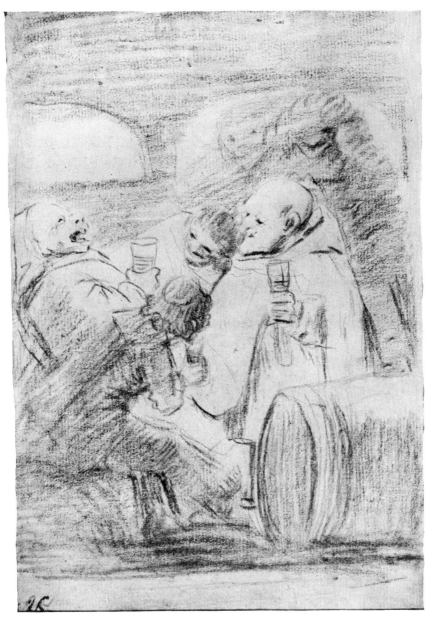

FIG. 249

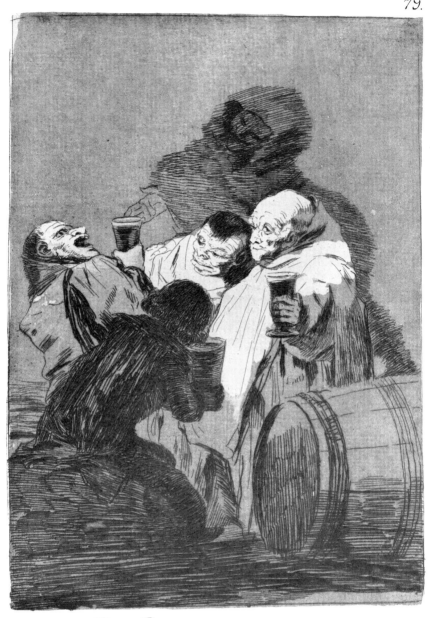

*Nadie nos ha visto.*

FIG. 250

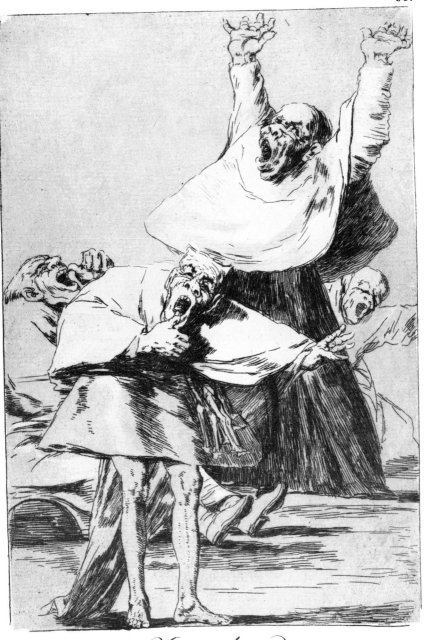

*Ya es hora.*

FIG. 251

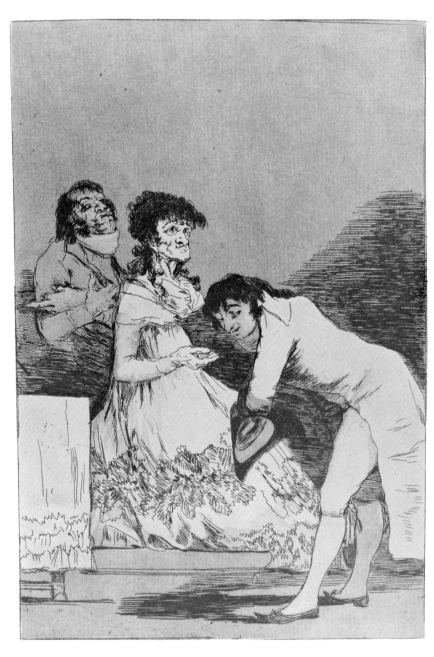

FIG. 252

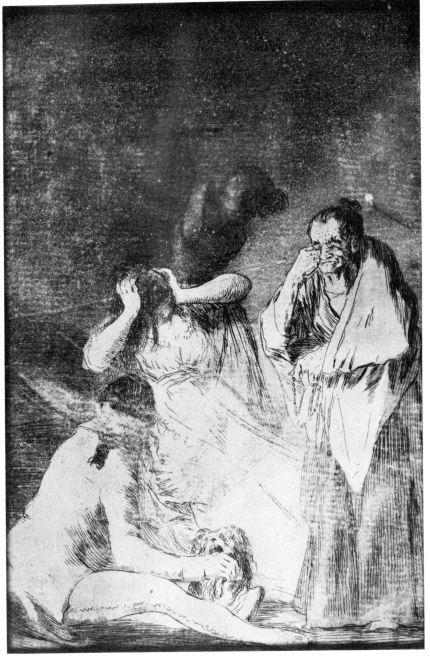

FIG. 253

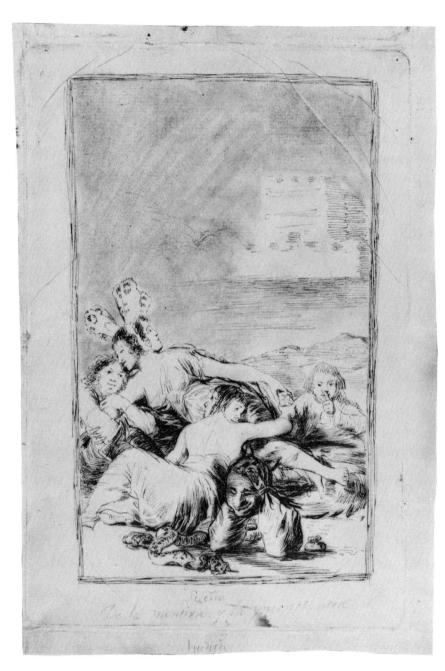

FIG. 254

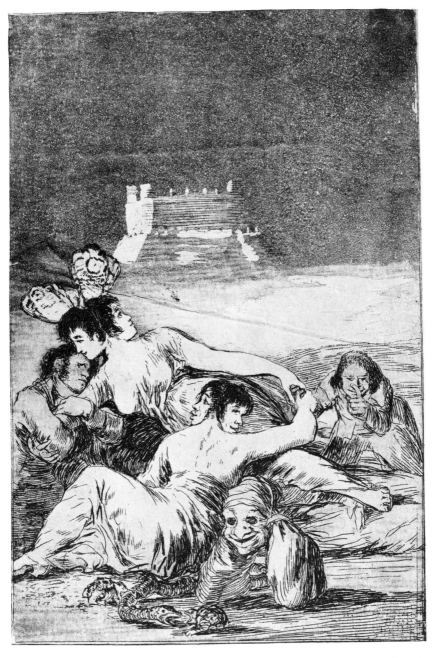

FIG. 255

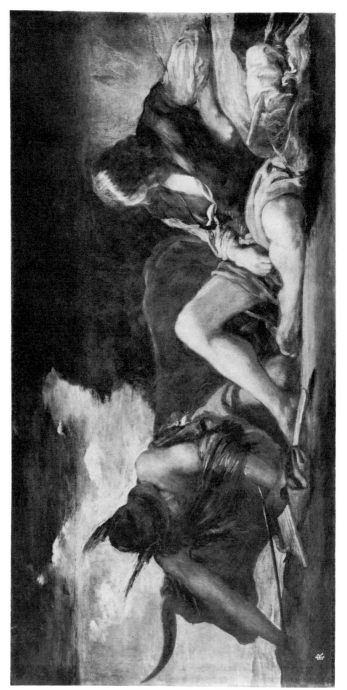

FIG. 256

Tab. XVII.1.

FIG. 257

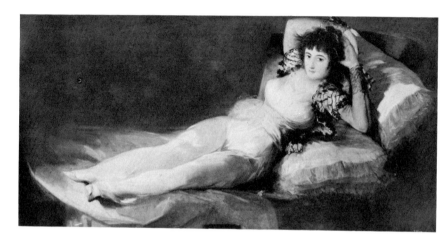

FIG. 258

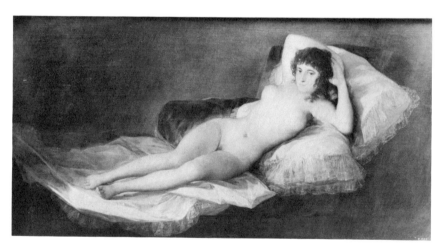

FIG. 259

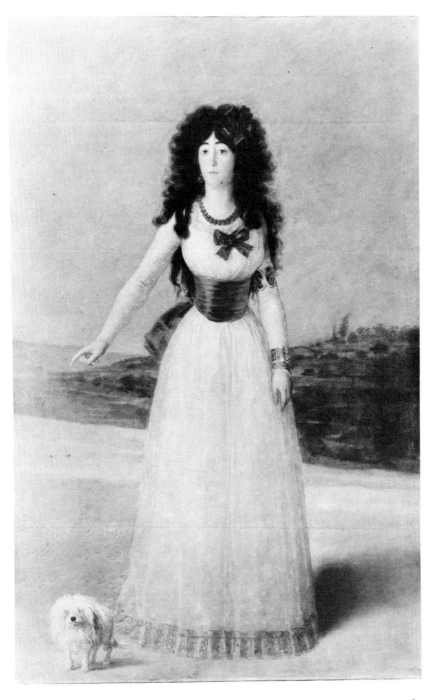

FIG. 260

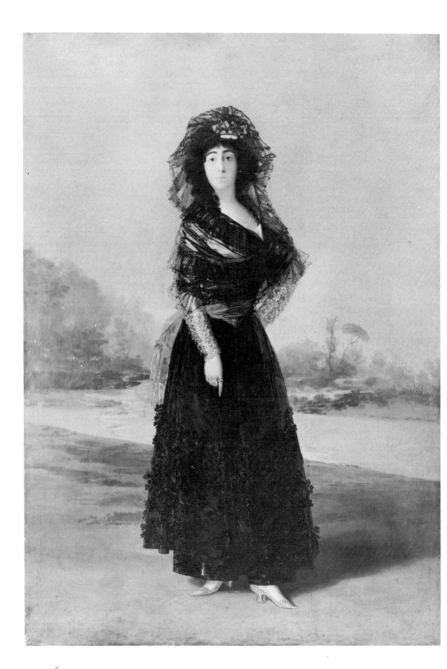

FIG. 261

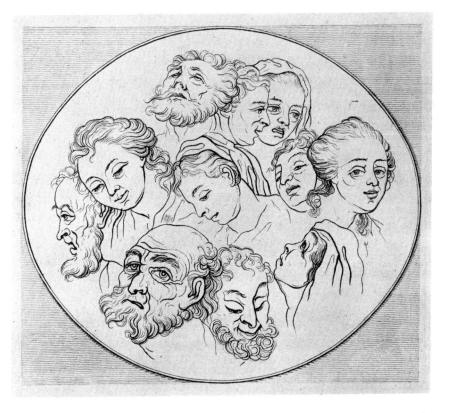

FIG. 262

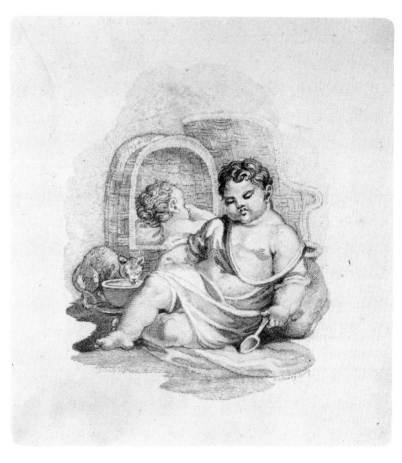

FIG. 263

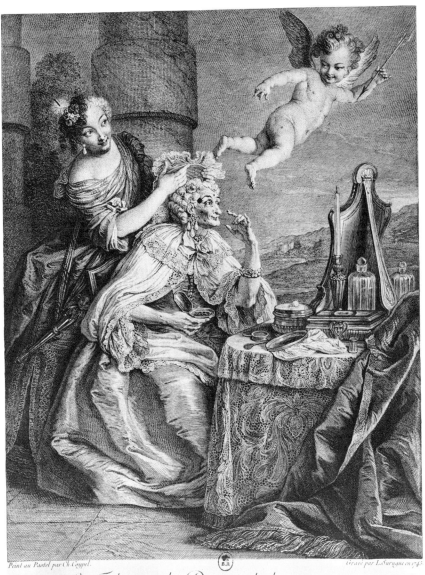

Peint au Pastel par Ch. Coypel.                                    Gravé par L. Surugue en 1745.

La Folie pare la Décrépitude des ajustemens
de la Jeunesse.

a Paris chez L. Surugue Graveur du Roy rue des Noyers, attenant le Magazin de Papier vis-a-vis S.t Yves. A.P.D.R.

FIG. 264

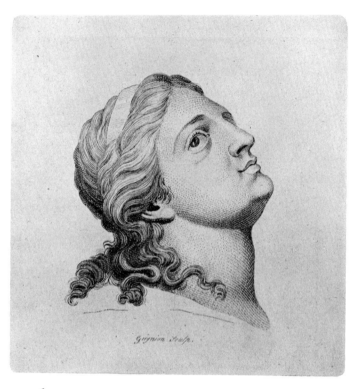

FIG. 265